The
Associated Press

PHOTO-
JOURNALISM
STYLEBOOK

The Associated Press

PHOTO-JOURNALISM STYLEBOOK

Brian Horton

ADDISON-WESLEY PUBLISHING COMPANY, INC.

Reading, Massachusetts Menlo Park, California New York
Don Mills, Ontario Wokingham, England Amsterdam Bonn
Sydney Singapore Tokyo Madrid San Juan

Many of the designations used by manufacturers and sellers to distinguish their products are claimed as trademarks. Where those designations appear in this book and Addison-Wesley was aware of a trademark claim, the designations have been printed in initial capital letters (e.g., Rosco).

Library of Congress Cataloging-in-Publication Data

Horton, Brian.
 The Associated Press photojournalism stylebook / Brian Horton.
 p. cm.
 ISBN 0-201-13235-4
 1. Photojournalism. I. Associated Press. II. Title.
III. Title: Photojournalism stylebook.
TR820.H64 1989
778.9'907049—dc20 90-22

This book was originally published under the title *The Picture* by The Associated Press. This Addison-Wesley edition is published by arrangement with The Associated Press. For information contact The Associated Press, 50 Rockefeller Plaza, New York, NY 10020.

Cover design by Robert G. Lowe
Text design by Baumann Resource Group
Set in 12-point ITC Garamond Light

ABCDEFGHIJ–HA–9543210
First Addison-Wesley printing, February 1990

CONTENTS

FOREWORD

Picture usage in American newspapers is changing – and changing dramatically. The role of photography in recent years has become more significant. The reasons are clear:

- Readers have come to rely on visual information more and more. That's traceable to television, the faster availability of still pictures and the growing expectation to "see" the story as well as hear it.

- Newspaper editors are looking more to design and to visual devices to tempt or interest readers into pages and stories. Editors are beginning to see pictures as storytellers in themselves; pictures, with captions, are often complete stories.

It all boils down to photography. And that's what this book is all about. It is a companion volume to *The AP Guide to Good Writing*. Together they delve into the mysteries of what newspapers are all about, words and pictures.

The author, Brian Horton, has a unique background for this volume. He is educated in journalism; he has worked as a photographer and covered virtually every kind of story; he has been a picture editor. In the latter capacity he plans the work of photography and reviews the work of photographers. He is young enough to recognize the good in the new; experienced enough to avoid the pitfalls and detours of the past.

The Photojournalism Stylebook is not a manual. Much has been written elsewhere about the technology of photography, how to operate cameras, how to judge exposures, how to crop pictures and plan a newspaper page.

The Photojournalism Stylebook is about the essence of photography, the editor's and photographer's minds at work seeking that most elusive of all journalistic ends,

a fine picture that tells those who see it something about their world.

The precious skill – "seeing" the story – is gained in a variety of ways. Education, experience, desire, knowledge, insight and the rarest factor of all, talent. And bringing all that together in one instant to provide a picture that tells us more than we knew before.

It takes some a lifetime to learn to do that. No one ever masters it all, completely. For the best photographer can be a foot to the right, or a foot to the left. And the poorest can be in exactly the right spot.

It's also true that some photographers are consistently luckier than others, and, we add, the harder they work the luckier they get. Or as one philosopher put it, "Chance favors the prepared mind."

What Brian Horton has done in this book is to take you into those prepared minds. *The Photojournalism Stylebook* provides an opportunity few other books on photography offer – an opportunity to benefit from the years of experience, the hours and days of preparation; to get some grasp of the insight, to understand the depth of dedication mixed with intelligence that good photographers bring to their daily tasks.

In short, the careful reader of *The AP Photojournalism Stylebook* will have the opportunity to share the telescoped experience and talents of others who do the job well.

Hal Buell
Assistant General Manager
AP NewsPhotos

ABOUT THE AUTHOR

Brian Horton has been around journalism virtually his whole life.

While still in grade school, he took phone calls and kept the scorebook at high school basketball games for his dad, a regional bureau chief for *The Indianapolis Star.*

In high school, he was a copyboy at *The Indianapolis Star*, doing some writing and photography for the newspaper.

While attending Indiana University, Horton was a stringer photographer for The Associated Press in Indianapolis, joining AP full time in 1971 on the Chicago photo desk.

Since then, Horton has worked as an AP photographer in Philadelphia and Cincinnati. In 1980, he was promoted to Ohio NewsPhoto Editor, based in Columbus, and in 1982 was named Photo Enterprise Editor for the AP in New York, overseeing enterprise and sports coverage.

In 1987, Horton was named the AP's LaserPhoto Network Director, handling planning for the AP's photo report to more than 1,000 newspapers in the United States. As part of the assignment, Horton is involved in the implementation of the AP's new PhotoStream program.

Horton has covered all types of news and sports assignments here and abroad, including spot news events, political campaigns and conventions, Super Bowls, the World Series, and Olympic Games in Los Angeles and Seoul. He has also lectured on informational graphics, electronic photography, and color photography and reproduction.

In 1987, Horton was honored by the National Press Photographers Association for his work in conducting more than three dozen clinics in the U.S., Europe and Canada for newspaper editorial and production personnel on achieving better color reproduction, and authoring a handbook on the subject, the AP ColorClinic manual.

In 1986, Horton and his wife, Marilyn Dillon, edited an AP book, "Great Moments in Sports," a collection of notable sports pictures from the wire service's archives.

Horton, 39, lives in New Jersey near New York City.

FROM THE AUTHOR

While talking with photographers and photo editors during the reporting phase of this book, I was struck by the amazing depth of knowledge that exists in our business - reporting with a camera.

No one was reluctant to talk with me at length, and no one ever failed to share the information that they had learned in difficult situations and through hard work over their years of being active photojournalists.

My goal was to provide the basic building blocks for a photojournalist. The reader will find few suggestions about what lens to use, or where to stand, but lots of what I feel is more important - the understanding of why certain lenses are selected and why you might want to stand in a certain spot. More of the concept than of the nuts and bolts, I would say.

My deepest thanks go to everyone who participated in this project. So many spent so much time and energy on my behalf. Many are quoted in the following pages or have contributed photographs, others lent support and ideas.

Some deserve special note. My wife, Marilyn Dillon, spent countless hours talking about possible topics, reading the text, and making suggestions. And the book's designer, Ruth Baumann, listened to every idea I had about how the book should look. Director Kevin Kushel of the AP's photo library, and his staff, helped round up the pictures.

Thanks to all of them. And to the many others who dropped me a quick note or called, or stopped by my desk to share a suggestion.

This book is dedicated to former AP staffers Fred Wright, Bill Ingraham, Jack Schwadel and Tom diLustro, who set professional and personal standards that will always be worth reaching for, and to Hal Buell, who has been such an important leader, teacher and colleague in my AP career.

Brian Horton
New York, 1989

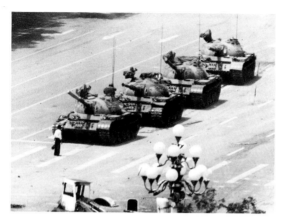
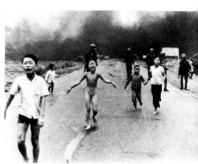
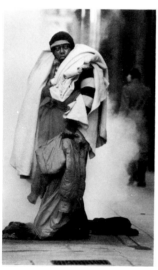
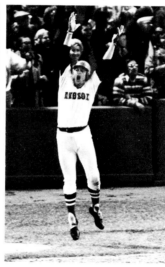
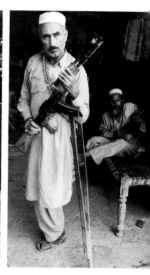
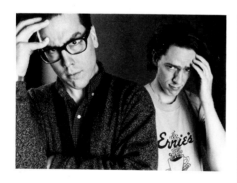
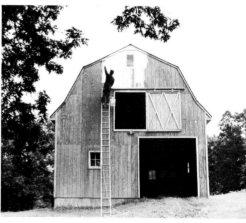

INTRODUCTION

It can be a picture of a child burned by napalm running along a highway in South Vietnam. A picture that would turn public opinion on a war thousands of miles away.

It can be a picture of a lone man standing in front of a column of tanks in Beijing's Tiananmen Square, symbolic of a mini-revolution to stop the actions of a government. Hailed as an image of a lifetime.

It can be a picture of Carlton Fisk, then of the Boston Red Sox, doing everything he can to keep a home run ball fair in the sixth game of the 1975 World Series. The key moment in the game that many baseball historians call the best ever played.

It can be a picture of an Afghan guerrilla proudly posing with his weapon, no fear in the eyes of a soldier who lost a leg taking on the Soviet army for his homeland. A portrait that captures the bravado and pride of the man.

It can be a picture, a portrait really, of a punk-rock duo. Boldly presented, an '80s group picture.

It can be a picture of a homeless person patrolling the streets, looking for a place to stay warm on a bitter cold day. An everyday battle some people would rather not see.

It can be a picture of a farmer in rural Kentucky painting his barn on a summer day. A slice of Americana.

It's all photojournalism.

Telling a story with a picture, reporting with a camera, recording a moment in time, the fleeting instant when an image sums up the story. Henri Cartier-Bresson called it the "decisive moment."

Happiness, sadness, accomplishment, failure, relief, fear, death - the mosaic of our lives captured on film, and soon on electronic disks.

Photojournalism isn't just a spot news picture made in a war in an exotic location far away. Datelines don't change the quality of the picture. It's also the local city council meeting where members are arguing about a tax increase.

It's not just a national magazine cover picture showing the key play from the Super Bowl. It's also the local high school team, anywhere in America, playing for the town's glory.

It's not just an essay on rafting down the Mekong River in Asia. It's also people keeping cool under a water spray on a hot day in your town.

Photographers covering the president of the United States or the mayor of a small town have the same mission - to make an accurate reporting of the subject's activities.

Photographers covering the Armenian earthquake, which reduced a region to rubble, or a smoky house fire that displaces a family have the same mission - to convey the enormity of the event in human terms.

Photographers covering the last out of the World Series or the last seconds of a high school basketball game have the same mission - to capture the essence of the winner's happiness, and the lonely moments and despair of the losers.

Moments that are part of our history - big and small.

In each case, the venues may be different, but the mission is the same - to inform, to report, to carry the scene to the reader, whether they are thousands of miles

away, or just down the street. To show them something they might not have had a chance to see themselves. To grab a moment of history and preserve it for the future.

J. Bruce Baumann, the assistant managing editor for graphics at *The Pittsburgh Press*, says it is important for the photojournalist to think first as a journalist, second as a photographer.

Baumann believes photographers need to reach out more for excellence these days. "It seems to me that the real guts of journalism, the reason I got in this business, is to make a difference," he says, "to present the lives of people, their joys, their fears, their happiness and sadness. To tell the world what is going on around them."

He believes there "just isn't enough of that going on now."

Baumann says photographers should be "looking for new ideas, new themes, breaking new ground, looking for things that are happening."

And Kurt Mutschler of the New Orleans *Times-Picayune* says a lot of those ideas can come from the newsroom. That's a place, he says, where many photographers don't spend enough time. "I think photographers are real lazy about becoming involved in the newsroom. They need to get involved in stories, talk to the reporters, find out what is going on."

From Matthew Brady's coverage of the Civil War, to the social reporting of Lewis Hine and Jacob Riis at the turn of the century, to the documentary photography of Walker Evans and Dorothea Lange of the 1930s, to the Life magazine photojournalists W. Eugene Smith and Alfred Eisenstaedt, to today's avant-garde images of Annie Leibovitz and Helmut Newton, there is a fine heritage of images to look at and study.

There are lessons to be learned from photographers who pioneered the photographic styles used today by

> *"It seems to me that the real guts of journalism, the reason I got in this business, is to make a difference."*
> — J. Bruce Baumann

countless newspaper and magazine photographers. And lessons to be learned by making pictures yourself.

Several years ago, a newspaper group ran an ad showing a photographer in combat gear. The caption: "Be prepared for a few cold dinners." That's certainly true for a photojournalist covering a war, but also true for a photographer covering the local scene.

Long days are the rule, with the stress of a hundred decisions a part of the everyday life. Will I be in the right place? Will I make the picture I want? Will I select the right lens and film combination to tell the story? When the moment comes, will everything I've learned give me the tools to make the picture that will tell the story of the event I'm covering?

Associated Press photographer Amy Sancetta explains: "You have to love this job because the schedules, the emotional ups and downs, the pressures would sometimes be too much if you didn't love it. It's a creative field. If you go to a game and make a good picture or shoot a nice portrait, you go home feeling great, but if you miss something, you go home feeling awful."

"I know what I need when I go out there," AP photographer Jeff Widener says, "and I really get down on myself when I don't get it." The pressure is constant. "I've got to make sure I'm getting a good picture each day."

And the burden of the news that you cover can be a heavy load.

AP photographer Bob Daugherty says that covering the Watergate hearings and aftermath was a tough, emotional job. He was photographing people under fire that he had worked beside for years on presidential trips around the world. "I found it to be a fascinating," he says, "but in the end, a very depressing time."

On the day President Richard Nixon would resign and Gerald Ford would be sworn in, Daugherty says he was thinking "it was like someone was taking a big rock off

your back. That morning it was almost a relief."

Ed Reinke, an AP photographer, recalls a bus crash that killed more than two dozen teen-agers on their way home from an amusement park. After days of covering the emotional scenes at cemeteries, churches and funeral homes, "I had come to the end of my line on what I could take." Reinke's answer after the story wound down was to "take a few days off and hold my own kids and think about how fortunate I am."

David Longstreath, also an AP staffer, calls it a balancing act. "Once you pull those cameras out, you're involved. You have to bear the weight of the comments and stares. You try to do it with a degree of sensitivity." The balance, he says, is to "be sensitive to their needs, but still do the job."

Thought, planning, and a good chunk of luck cut down the chances for failure, but the photographer has to be prepared, whether on the biggest assignment of his career, or the pet of the week at the animal shelter, to bring back the picture that really tells the story to the reader.

Reinke says it is the art of being able to go with the flow, with some control. He explains, "I think it becomes a thinking person's game. Anyone can stick a camera in the face of the obvious, but a truly good photojournalist will look at the situation and the light that is there, and the light you are carrying in your bag, and the cameras and lenses you have, and make the best possible picture out of what you have."

"That is what separates a good photographer from a mediocre one, " Reinke says, "the ability to go with the flow, but also to have a general idea of how the flow goes."

Longstreath describes that "flow" management another way. At a news scene, he says, "You throw your antenna out, you look, and you size it up. Pretty soon you see your opening, and you're in."

Photographers must have "the ability to go with the flow, but also to have a general idea of how the flow goes."

— ED REINKE

As famed Green Bay Packers football coach Vince Lombardi used to tell his players, "Luck, that's where preparation meets opportunity."

Jack Corn of the *Chicago Tribune* compares photojournalism to baseball. "There aren't any absolute answers, you play a new ballgame each day, in how far you can push the rules in photography and journalism."

Corn says success can often be measured by the dedication and hard work of the photographer. "Some people just try harder than others and that is what it boils down to," he says. "You can teach anybody to do photography, but it is that sense of timing and energy and journalism that makes the difference in people," and separates the average photographers from the talented ones.

Great photographers come from a variety of backgrounds. As children, many began making pictures with a simple box camera, developing the film in crude darkrooms set up in the family's bathroom. They watched the contact prints develop in little trays balanced on the edge of the sink while family members waited impatiently to use the facilities.

For AP photo editor Harry Cabluck it began in high school when he raced to auto accidents, alerted by the dispatcher at his family's towing business, in hopes of making a picture. Then he'd try for a sale to the local newspaper or, perhaps, an insurance company. On weekend nights, he'd troop up and down the sidelines of Texas high school football games, making flash exposures powered by a homemade car battery setup.

Daugherty got his start on the high school newspaper and yearbook in Marion, Ind. But, at the tender age of 15, he moved to a full-time spot on the local newspaper's staff. Before long, he was working at the state's largest paper.

To learn about photography, Daugherty studied the Indianapolis newspapers. One of the photographers was

an expert in shooting in available-light situations, two others "could do wonders with a single light." Later, he would work beside many of the photographers that he had studied so carefully when first starting out.

Even then, he kept on looking at pictures. "A paper I always watched was *The Milwaukee Journal*. It was required looking, the daily bible."

Others, like Reinke, took up the profession after getting a camera as a high school graduation gift, asking friends for help in the basics of loading the camera and adjusting the aperture and shutter speeds. He credits his college photojournalism professor, Dr. Will Counts of Indiana University, for his direct, honest approach to photography.

He says of his visual style: "The single thing that influenced me was 'Self Portrait: USA,' a book by David Douglas Duncan." Reinke says that book, a collection of Duncan's photographs from the tumultuous 1968 political conventions in Chicago and Miami, opened his eyes to a way of making pictures that he still aspires to today.

> *"The journalism part is important, my job is not just to take pictures, but to impart information."*
> — MARK DUNCAN

AP photographer Mark Duncan went to college and drove an oil truck for his family's business, making pictures in his spare time before moving into his first full-time staff job in the photo department of the *Dayton Daily News*.

"Go to college and get a degree in photojournalism," he tells prospective photographers, "and have the opportunity to have internships." Duncan studied computer science in college. "I am grateful for my computer background because of where the industry is going, but more journalism would have balanced that. The journalism part is important, my job is not just to take pictures, but to impart information."

Some photographers, like Longstreath, learned the fine points of their craft in the military, starting with basic documentation tasks and advancing to elite camera groups

and advanced studies. From a high school photo course, to a job as a "lab rat" for the FBI, he went on to the Navy and more formal training, before leaving the service and moving into daily photojournalism.

The military gave him great training and a chance to work with some excellent photographers, but, "after assignments in 33 countries, I had personally witnessed too many pierside goodbyes," Longstreath said.

AP photographer John Gaps III got into photography after being the subject during his days as a prep football player. Gaps tells the story. "A photographer showed me some pictures that he had made of me playing football in high school. Later, I went to his darkroom and I thought that was pretty neat. And then one afternoon in college, I had a choice of going to football practice or finishing a project due in my photography class."

"I gave up football for photography," Gaps says, laughing, "and the coach was real supportive." Gaps explains he wasn't NFL material on the football field. He did, however, get to an NFL conference championship game. With his cameras. And, Gaps now has numerous regional and national awards, and top assignments, to his credit for his photography.

Rusty Kennedy, an AP photographer, says working everyday with the veteran photographers at his first job, an internship on the photo staff of the former Philadelphia *Bulletin*, was really his education. "I was really lucky to have learned from them. Each had an area of expertise. One was good at fashion, one was good at studio, and so on. I could watch and learn so much, then try it myself."

Kennedy says you can only get so much from a book or watching, though. "Photography is really such a hands-on thing that you have to do it yourself," he says.

Those work experiences are important, Mutschler says, because they give the young photographer a taste of the real world. "College photographers' portfolios are full of picture pages," he says, "and the real world is more a

one-picture situation." Often, "they don't have fashion, they don't have illustrations." Mutschler says there are exceptions, but "90 percent don't have what they need to get hired."

Longstreath believes you learn from everything you see, and you try to keep on learning. "You learn by looking at pictures, by asking how did they do that? You store it away for another day." He, too, feels you learn a lot by simply making pictures. "What worked once may work again with a new twist."

New York Times deputy picture editor Nancy Lee says photographers should "always consider what isn't always obvious. That is what is behind the news. It might make a better picture. And don't follow the pack. Some of my favorite photographers pause a few seconds before they push the button looking for a different moment, or if everyone is on the right, they move to the left," she says. "If it doesn't work out, OK, but sometimes it will end up paying off."

> *"You learn by looking at pictures, by asking how did they do that? You store it away for another day."*
> — DAVID LONGSTREATH

And, you need to be critical of your work. "The minute you are satisfied with the way things look," Longstreath says, "that's the time to quit. You should be constantly striving to improve yourself and your craft."

"There is no such thing as good enough," Longstreath says.

The common thread that keeps all of these photographers in the business is the joy of seeing negatives on their film for the first time - and after subsequent assignments - or the print coming up in the developing tray. Or, to screen the slides they've shot and see the impact that they had hoped for.

Daugherty says he thought photography was for him when "I saw my first print come up under the yellow safelight in that tray of Dektol. Then, when I saw the first run of the newspaper," he says, he was hooked for sure.

He can't remember that first picture, but laughs and says, "I'm sure it was the best picture I ever made."

The thrust of photojournalism as we know it may be changing, according to *San Jose Mercury News* senior picture editor Sandra Eisert. She worries that quality photojournalism is becoming too expensive for all but the most committed newspapers.

"I worry we aren't spending enough time looking and thinking. We spend too much time on sure bets. That takes the depth, the surprise, the newsiness out of what we do," she says. "I just think that good journalism takes time, and the depth of it has become a little too expensive."

Eisert sees less meaningful photography in the future, like documentary projects and complex picture stories, as photo departments are pressed to get more bases covered with smaller staffs. "In the future, I can see newspapers settling for one picture on an interesting topic, rather than something with depth."

After you've worked as a photographer, where do you go? Baumann isn't optimistic about the upward mobility for photographers. "There is not, for no practical purpose in this country, any place for a photographer to go beyond being an assistant managing editor for photography or graphics. And, if you look at it, today there is no real difference from when we had picture editors. All they did was create a myth," he says.

Baumann says there is no lack of qualifications though. "The visual people may well be the most qualified people we have. They're organized, they are the only people who work with every section of the newspapers. But, what kind of track is there?" he asks. "If you're good, you can have a meteoric rise and you can become an AME Graphics in your mid-30s, and do that for the rest of your life. Under the present system, there is nowhere else to go. It is a terrible waste of talent."

Eisert believes there is a secondary penalty for photographers as they grow older. "It can be physically more demanding and harder to move around," she says, as the years of carrying heavy equipment and working long hours in difficult situations take their toll. "They need to find something that doesn't require so much stamina and strength, and there is nothing there."

Another disturbing situation about the business to some is the influx of automated equipment. Some photographers believe that the human element is being taken out of photography. As we head into the age of "smart" cameras, and then into electronic picture handling, less "human" and more "machine" seems to be creeping into the equation, they say.

AP photographer Doug Pizac says the "thinking" part of the business is the most important. But, he says, "There doesn't seem to be very much of that today, what with all the automatic cameras, strobes, film processors, print processors," and other pieces of automated gear that are taking the thinking away from the photographer.

"And once you stop thinking, you start working for the camera rather than letting the camera work for you," Pizac says. "And, without thinking, one of the most important aspects in photography, creativity, is lost, too."

> *"Once you stop thinking, you start working for the camera rather than letting the camera work for you."*
> —DOUG PIZAC

Reinke hopes we don't lose touch with our heritage. "I hope we never lose the ability to get in there (the darkroom) and get our hands wet. I think we'll lose a little bit from our craft if we do."

"It is a craft," Reinke says, "just like a man being able to lay a straight row of brick. Ours is a craft to expose the film properly, making a picture that tells a story, and then make a print that isn't burned too much or dodged too much and is presented properly."

Your pictures the way you imagined they would look.

Sancetta says: "I know I feel better when I've done a good job, made a good picture. If I can go out and make a good picture, something I can be proud of, it makes my whole week."

That kind of thrill never really goes away. The most jaded professionals, after particularly tough assignments, still want to see the pictures as soon as possible to see if their ideas worked.

Reporting with a camera. Capturing the instant for others. The "decisive moment." Photojournalism.

George Wedding, the director of photography at *The Sacramento Bee*, calls it "holding a mirror up to society, so society can look at itself."

This book is written under the assumption that you already know how to operate your camera, expose your film, make the simplest of prints. It will attempt to take you beyond that. Picking the right angle, the right film, lighting the situation if needed, discussing philosophies of photographers on how they cover a broad range of assignments, and the future, electronic photography.

"The Picture."

In simple terms, it will introduce you to the basics of good news photography.

THE LOOK:
Composition, Style, Cropping

There are three forces - composition, style and cropping - that control the look of your photographs.

Composition is the collection of elements in the picture, and how those elements compete for the readers attention. As the eye tracks across the pictures, the position of those elements, the composition, makes the eye move on or stop and study the image.

By approaching your photography so that the composition - the look of the pictures - is consistent you will develop a "style" that identifies those pictures as being yours.

Cropping is including, or excluding, elements as the picture is made, or later in the darkroom, or at the editor's desk.

All three disciplines - composition, style, cropping - are tough to teach, according to several professional photographers and picture editors.

Developing an individual style is a challenge.

"As an editor," George Wedding of *The Sacramento Bee* says, "I see very few photographers who have a unique style." He thinks that is because "in contests, books and seminars, we identify and create standards that we teach people to aspire to. And, generally they help us identify a standard for quality. But, one of the problems is that you see a lot of portfolios that follow those examples of styles to the point that the individual photographer's own style is lost."

"The business of photojournalism is to communicate something to somebody," says Sandra Eisert of the *San Jose Mercury News.* "If what you are communicating is more about who you are rather than what they are, that's not right." Some photographers always use wide-angle lens, others shoot too tight. They "never look at the context of anything," she says. That's the simple look at style, she says, but "it gets much more personal, much more internal than that."

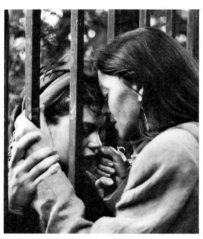

Diether Endlicher's picture of an East German mother saying an emotional farewell to her daughter at the fence surrounding the West German embassy in Prague lets the content, not special effects or exotic lenses, tell the story.

Porter Binks of *USA Today* says as photographers starting out, "we've got our hands full just mastering the techniques of the camera and the film and training our eyes to see and our ears to hear. We hardly have time in a lot of our positions to think about style. If something develops over a period of years, that's fine."

Binks thinks the look of a photographer's pictures, created by using certain lenses or certain angles, may be "better defined as a habit that turns into a style."

Some say a feeling for composition is either there, or it's not.

"I guess that my first thought is that composition is something you have to have a feel for," says Mimi Fuller Foster, a long-time photographer who is now an editor at *The Atlanta Journal and Constitution.* "You may learn it over a period of time, but you have to have some feel for it in the beginning. If you can't see it, it's real hard for someone to tell you how to get a sense for it."

"Composition is felt," AP photographer Bob Daugherty says. "A good picture is felt from the heart. The heart skips a beat at the right moment."

And there are differing views on cropping. Some editors say that it is an important tool, others feel it should be avoided if at all possible.

Alex Burrows of the Norfolk *Virginian-Pilot* is on the side of sparingly cropping the work of the photographers on his staff. "I think a crop is an opinion," he says, "and that opinion should be expressed like a sentence. You should express it with care."

Foster doesn't favor massive cutting, but feels "cropping is something that can make almost any photograph look better. There are few pictures that can't be improved," she says. "The world doesn't fit perfectly into a 35mm frame." Foster agrees that cropping is one person's opinion. "Some of it is arbitrary," she says, and "it's a matter of the taste" of the editor.

Editors and photographers are talking about the effect of television, advertising and magazines on newspaper photographic styles.

"I think that in journalism," Wedding says, "simply being able to do documentary photography is no longer the only tool or technique of photographic style. Illustrative and conceptual photography is another style that is becoming increasingly important."

He believes "the evolution has been influenced by television and innovative lively programming like MTV. After all, many videos are a series of still photographs, set to motion," he says. "A lot of glitzy techniques are used, but they are really a series of still pictures, beautifully conceived and cropped and managed. Each one in itself is a perfect still picture."

Wedding thinks these new kinds of imagery "are having a profound effect on journalism and news photography. There is an idea that is evolving that pictures have to be cosmetically perfect - perfectly composed, perfectly cropped and perfectly lit - and this idea has evolved from those forces, television, the movies and advertising."

Those forces "raise the visual sophistication of readers and viewers," Wedding says, "and force us to be better visual communicators. It makes it more difficult for traditional documentary photography to be competitive with sophisticated, cosmetically perfect images."

Foster also sees a change in the public's visual sophistication. "I think we are becoming more visually sophisticated, what with television and especially MTV. You can't help but be influenced by that stuff," she says.

She says that, generally, the rise in the level of visual sophistication among the readership is good. "People are expecting more visual excitement. Magazines, TV, advertising, billboards, everywhere you look," says Foster, "the visual things are so complicated and sophisticated, people are influenced more. Now the general public's taste has been upped a few notches, it's gotten better."

Wedding feels ultimately, however, that these "cosmetically perfect pictures" will never replace good documentary photographs.

"A good picture with good content will always will be better than pretty pictures," he says, "but the steady diet of pretty pictures is forcing us to raise our standards in producing the documentary pictures that aren't always cosmetically pretty." He says up to now it's been a comparison between "the raw gritty black and white news image with a beautiful color illustration," but that the level of quality on the news picture is being raised to compete for the reader's eye.

"It is helping us to raise the technical standards," Wedding says. "Good prints, good composition, and good cropping are becoming more important." And that's OK with Wedding. He thinks that anything that will improve quality is helpful.

Burrows thinks this new style of photography will only slowly begin to creep into news pages, destined more for the feature sections. "I think newspapers are

pretty conservative in their approach in the news pages, and that is justified."

But he sees that being tested. "A photographer is always reaching to make better, more visual pictures," Burrows says, "stretching the envelope, while editors are trying to slow that move."

"It is important to understand the distinction between the two styles," Wedding says. "Conceptual is whimsy and fantasy, and documentary is reportage and observation, and it is real."

Wedding feels that some newspapers are sending mixed signals to their readers. "Some editors have contributed to the problems because they are allowing mixed standards," he says, "and some photographers have contributed by blending a conceptual idea with a documentary style. When you mix the two, you sometimes run the danger of confusing the readers."

Burrows is concerned about this possible confusion, not wanting to "disturb the reader with gimmicks in the news pages. You have more liberty in the features department, changes come more easily there than in the news pages. Feature sections are more wide open," he says, "and readers now sense the difference."

> *"Conceptual is whimsy and fantasy, and documentary is reportage and observation, and it is real."*
> — GEORGE WEDDING

"I certainly hope I am not seeing a blurring of what is real and what is not real in the news pages," Louisville *Courier-Journal* photo and graphics editor C. Thomas Hardin says. "The public wants to think the newspaper is slanted anyway. I don't think we need to give them any ammunition. I hope we are making the conceptual illustrations so obvious that they can't be confused with reality, with real situations."

Wedding feels all of these changes will settle into their own niches in time, that the distinctions between the "conceived" pictures and the "real" pictures will be

obvious. "Over the long haul, documentary photography will come to be viewed as we now view button-down collars and wing-tip shoes," Wedding says. "It will never go out of style."

This emphasis on composition and content, coupled with the new ideas and techniques that photojournalists are being exposed to, is leading to more photographs becoming visual statements, with the imprint and input of the photographer in each picture.

"I think some of the really top photographers have a style because they have a keen eye," says Hardin. He says they gather information in the camera's viewfinder "and they are cataloging that information in the frame. They have a sense of how that information should be cataloged and how it should be presented to the reader."

> "Documentary photography will come to be viewed as we now view button-down collars and wing-tip shoes. It will never go out of style."
> — GEORGE WEDDING

If that all comes together in a style, Hardin says, "the reader benefits because the end result is highly informative, highly packed, cleanly visual news photographs."

The sense of "style" isn't new to news photography.

AP photographer Rusty Kennedy says W. Eugene Smith's style is timeless and has served as an example to many photojournalists. "I think in the beginning, most people that I knew who were serious about photojournalism wanted to emulate people like W. Eugene Smith and the photo-essay concept. You got a seed of an idea and tried to develop it, and you tried to have a set of pictures with at least one really strong one."

"Many of the things he did, like the rural doctor, you could have used those ideas on anyone," Kennedy says. "Real dramatic black and white photography."

Wedding says photographers need to work to have a style of their own. "It's important to develop a unique point of view to create a unique style." And, editors

should push their photographers to develop a style. He sees the editor's goal being "to help photographers develop their own unique style of photography, so they can communicate their own unique view in their photography."

He proposes a possible change that goes to the very heart of journalism.

Wedding says while photojournalists have traditionally been "taught to be objective, I have come to believe that is an admirable goal, but not an attainable goal."

"Each of us are unique individuals, we are all a product of our background and environment," he says, "and we've been influenced by the good and bad people we have known and have formed opinions that are difficult to shake." Wedding thinks these feelings will show in a person's photographs.

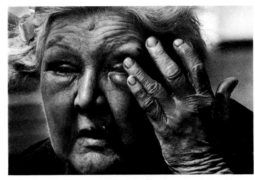

Rusty Kennedy's portrait of a homeless woman in Philadelphia is an example of his intense, personal style of photography.

He thinks now might be the time to be open to subjectivity, instead of demanding the objectivity we have always held as a standard.

"A more reasonable and attainable goal to strive for," he says, "and a more interesting style of journalism, is to be subjective." Wedding feels it is "OK to be subjective, but you've got to be fair and accurate. I think if you treat your subjects with fairness and you report with accuracy, taking a point of view and being subjective in the story is more realistic of what we do for a living."

He says, "I don't think it's possible to always put aside your biases. We should strive for it, but the most

interesting stories, and pictures, are observations where a knowledgeable and educated person takes a point of view and knows how and when to hold a mirror up for society to judge itself by."

"The most successful photographers," Wedding says, "are the passionate photographers with a story to tell and a message behind their pictures."

He says that these stories and pictures with a viewpoint take a more considered approach to editing. "The most intimate stories take a point of view, and that puts a greater burden on the photographer and editor to be fair," Wedding says. "You have to make sure you are reflecting both sides of the issue. Ideally you'll get it all in one picture, but you aren't always going to get that."

That's why a photo essay, which allows several pictures to be included to give a variety of views, is a better vehicle for this approach to photography. "In editing, you can help ensure that you're adding pictures that give balance," Wedding says. "That is why the photo essay is so important for the subjective style of photography."

Foster doesn't think we are ready to abandon objectivity, but does think, "we don't have enough photographers taking a position with their pictures. I want a photographer to have a point of view," she says, while maintaining standards of fairness and objectivity.

"I just always favor objectivity," Eisert says. "Truthful is the best we can hope for. We should always strive to be objective, but we should be truthful. But trying to be truthful, trying to be objective, doesn't mean you have to throw your humanity out the window."

The decision to make the picture is based on the photographer's life experiences, so it is subjective in one sense, but the message should be objective. And, most of all, the message should be clear. "At some point, you have to say to yourself, this is what is happening and if you

can't figure that out, the reader probably never will either."

Jack Corn, the director of photography at the *Chicago Tribune*, agrees with Eisert. "Ideally the goal would be to be as objective as possible, but I don't think that is always possible. The great photographers are the ones that are passionate, that feel a burning in their guts." Corn says everyone carries "intellectual baggage" that helps shape their responses. "To try to deny that is wrong," he says. You just want the photographer "to be as fair and honest as possible."

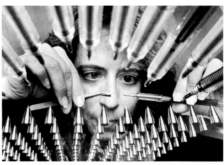

Careful handling of props and lighting draws the readers' eyes to the product in this photograph from a ballpoint pen manufacturer.

Corn says he watches the work of the photographers and "I ask questions a lot." That helps him hold the line closer to the side of objectivity.

New York Times deputy picture editor Nancy Lee thinks an editor shouldn't try to alter a photographer's style. She believes that having a unique style is important to the photographer. "I don't believe that should be discouraged, it is from the soul. Discouraging a photographer's style takes away the personal creativity. It's like changing a batter's grip, it is dangerous unless there is a real reason to do it."

And Lee thinks those reasons are limited to continuing cases of the photographer only shooting one type of picture to the exclusion of something closer to the story, or using a technique in a situation where it is inappropriate.

If photographers do begin adopting a definitive style, the danger does exist that their style may become more of a statement in the photograph than the information the photographers are trying to relate.

Corn warns against a heavy-handed style and says some photographers seem to forsake their journalism for a "look" to their pictures. "They want to leave their tracks," he says, "leaving the black edge of the frame in, having a flash show, tilting the camera." Corn says, "If your photography is good enough, you don't need to do that."

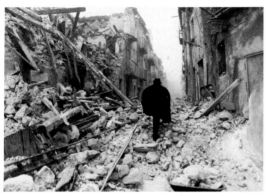

"I think that you have to be careful when you are talking about having a style," Indianapolis freelancer Mary Ann Carter says, "because the job of a photojournalist is to tell a story and communicate. If you forego that goal for the sake of a style, you're not doing what is important."

The crumbling walls of buildings destroyed in an earthquake in Balvano, Italy, frame a lone man as he makes his way across the rubble in this photograph by Gianni Foggia.

Carter explains that "it's OK to have a style, like using a blue gel or using an extremely wide-angle lens, but if your style precludes you from being a communicator, maybe it is not such a good style for a photojournalist."

"Sometimes you have to adapt your style to the story you are covering," she says. "Photojournalists have to be able to shoot a lot of different things - sports, news, and features."

She warns there is a danger to adapting a style that has no flexibility. "One day you may be shooting something where a blue gel or a wide-angle lens is fine, but the next day it might not work at all."

AP photographer John Gaps III feels he adapts his style to the circumstances of the coverage he's involved in at the moment. "By now," he says, "I have two different ways of shooting: when you take pictures for yourself, and when you take pictures for someone else."

On a sports assignment, "I always try to do that for myself," Gaps says, using "a tighter lens, a wider lens, a different angle."

But on a breaking news assignment, "when there is a lot flying and I'm right on deadline," he says, "I try to get what an editor would want to see. Then, when I've got that clear, I say, 'How do I see things?'"

Gaps' early photography also was influenced by the work of W. Eugene Smith, and several photographers from the region where he attended college. "W. Eugene Smith was everything, but also Rich Clarkson, Jim Richardson and Brian Lanker in Topeka. I got exposed to that group's photography a lot because my college professor would invite them up for lectures."

Daugherty boils his style down to one thing - simplicity. "I don't like to introduce too many elements into a picture."

At the risk of being called single-minded in that respect, Daugherty says his photography mirrors the approach he tries to take in life. "I don't like to have too many loose ends, in my work, and in my life. A good picture is generally a single subject, not a lot of loose elements."

Carter says she defines her style as a personal approach to the people she photographs. "My style is to respect people and try not to put them in situations that denigrate them or belittle them." She says she takes a simple approach. "I think you have to treat people the way you want to be treated." She calls this "a gentle determination."

Carter is also exposing herself to other ways of forging the visual makeup of her pictures. "The way I'm trying to improve my eye overall is that I took a drawing class, and I study the techniques of artists," she says, "and I look at photographers who are not photojournalists. And I try to look at photographers who are better than I am

and see what they are doing and try to spark my mind in those directions."

She says that the drawing class has taught her the theory of getting into a right-brain mode. Carter explains that your brain operates in two sections, with the right brain handling artistic functions and the left brain handling logical functions. "Photography is a right-brain activity, it's creative," she says, "and the class was based on getting into the right-brain mode. If I can do that, it should help my photography."

AP photographer Susan Ragan also credits her art background with giving her a sense of composition. "From my art background, I think about composition and beauty and balance that may not be so evident to other photographers." Ragan's training includes a Fine Arts master's degree in drawing and painting. She didn't take up photography until she had several years of art training behind her.

"Maybe that made me sensitive to different pictures," she says. "I think I have a sense of composition and light from that training." Ragan says, for instance, "I know when there is Rembrandt light on someone from the art training I've had."

The use of smash closeups, isolation with long lenses, strong lighting techniques and different perspectives give pictures a different look. Some of these techniques are rooted in painting, others in the styles of avant garde photographers.

Old style, or new, good composition means pictures that are interesting to look at. That's the simple definition.

J. Bruce Baumann, the assistant managing editor for graphics at *The Pittsburgh Press*, sums it up with a no-frills explanation. "If something doesn't need to be in a picture, it shouldn't be there. You accomplish that by where you stand and what lens you use."

Larry Nighswander, a former newspaper photographer and photo editor who is now an illustrations editor at *National Geographic World* magazine, says that beginning photojournalists should start with the basics of composition. "There is no doubt in my mind that one of the first things a young photographer needs is a command of these visual devices."

Those "visual devices" are the concepts that make a picture more interesting to look at. Ideas like the rule of thirds, linear perspective, framing, the "decisive moment," selective focus, controlled depth of field, perspective, and others should be in the photographer's basic "tool kit."

Photo editor Larry Nighswander has identified 15 elements of composition that can control the "look" of your photographs. Some pictures contain one of the elements, others will use several of the elements.

The elements are:
- rule of thirds
- linear perspective
- framing
- silhouette
- the decisive moment
- selective focus
- dominant foreground, contributing background
- controlled depth of field
- introducing disorder into a controlled situation
- texture
- juxtaposition
- reflection
- panning
- perspective
- lighting as a creative device

If you take an extremely creative photo, Nighswander says, and dissect it, "it can contain four or five creative devices. Each helps strengthen the power of the photograph."

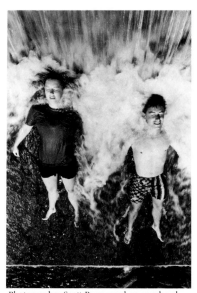

Photographer Scott Perry used an overhead walkway as a perch to make this different view of youngsters cooling off in a Wayne, Maine, dam spillway.

He says no matter how much experience you have, these visual devices can make your pictures better. "Every time I take a picture, these things click through my mind. I'm always thinking, which ones can I use?"

Carter says an easy way to improve a photograph's composition is to merely change perspectives. That's one of the visual devices.

"You have to move around a lot," she says. "You have to watch shooting everything from eye level." You can shoot "on a ladder, or on your knee, or on your belly" to get a different view.

For instance, Carter says some of the pictures her children shoot are interesting, just because they are shot from a different perspective. "When you give a kid a camera, they are going to shoot everything at their eye level. That's your knee level, and it's an interesting view."

Carter says photographers should vary their perspectives as much as possible. "Too many pictures from the same perspective makes the reader lose interest," she says. In fact, she says, using any of the visual devices too often will dull the reader's response.

New Orleans *Times-Picayune* picture editor Kurt Mutschler agrees, and says photographers have to try for a variety of images. He says photographers often go to an event and shoot like "their feet are in concrete. I see 36

exposures from the same spot, with the same lenses. They don't experiment, they don't try for something different."

When looking for new photographers for their staffs, Mutschler and several other picture editors say they want to see contact sheets from two weeks or more. "When I'm hiring someone," Mutschler says, "I ask them for contact sheets from the past two weeks. That way I can see how they move around and how they use their lenses to try for different pictures."

Burrows believes that knowing how the picture is going to be used will help the photographer get the most mileage out of those creative tools.

The first thing that is important for the photographer heading out on an assignment, Burrows says, is "to know what you are shooting for - A1, inside, secondary play, the feature section. You have to know the audience you're aiming for."

He says you should make different kinds of pictures for different uses. "For instance, if you are shooting an assignment for a column," Burrows says, "you might be shooting for a small picture. So you would want to go for an impact image." On the other hand, "if you are shooting for the main picture on A1, and they'll use a four-column picture, you can shoot a looser photograph."

However, if the newspaper doesn't generally display pictures that size and that same assignment is going to be used slightly smaller, it could change the composition of the picture needed. "If it is a three-column instead, you have to shoot for a little more impact," he explains. "The bigger the general size, the more flexibility on the looseness. A small picture needs more impact."

To give that smaller picture greater impact, Burrows recommends that the photographer concentrate on the person's face and have fewer, simpler elements. He says that is important on a small picture so the reader's eye won't be confused with the clutter.

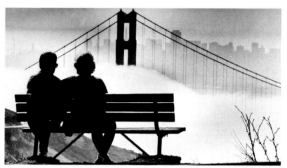

The use of the silhouette technique mixed with an eye for the lines of the Golden Gate bridge make Eric Risberg's quiet feature a pleaser.

On the picture to be played larger, a looser composition works. "You still have to keep an uncluttered picture," Burrows says. But he says that the elements of the picture don't have to have the same boldness, the same impact, that is needed when the picture is going to be played smaller.

The best of both worlds, Burrows says, "is to have the real impact in a large picture. That's the maximum impact."

AP photo editor Harry Cabluck thinks there is an easy way for photographers to improve the impact of pictures. It's the choice of the lens they'll use.

Cabluck says you can shoot the same scene in a more readable manner by using a longer lens, even if you have to take a position farther from your subject. The subject will be crisper, because the depth of field is not so great, and the scene will be more pleasing to the eye.

And, another lesson from his days at the Fort Worth *Star-Telegram* is "to shoot vertically as often as possible and have a camera that is easy to hold vertically because the newspaper pages are vertical and it is easier to do the makeup with a vertical in mind."

Cabluck says photographers sometimes forget who they are shooting for. "The reader," Cabluck says, "that's who we are doing it for."

Others say that too much of anything - horizontals, verticals, closeups, wide shots - should be avoided.

When assigned to produce more than one picture on a subject, Nighswander stresses, the still photographer

"ought to think like a film director, making closeup, medium and overall views." This variety will result in a visually appealing picture story.

"Just as a film director wouldn't shoot from one perspective and with one focal length lens," Nighswander says, "a still photographer needs to compose the story with different perspectives and focal lengths to give visual variety to the story."

It all goes back to the guidance the photographer had before shooting the assignment, Burrows says. "The more the photographer has input where the picture is going to be used, the better. That means good direction from the picture editor or section editor" about the editor's intentions for the photo's play.

After the photographer has decided on an approach to photography, and used the visual devices to compose a picture, the decision has to be made whether to use the picture as a "full-frame" image, exactly as it was made in the camera, or if the framing needs to be altered.

This decision sometimes falls on the photographer, other times on an editor.

When it is decided that a picture should be cropped, some want the photographer to have and exercise that option. Others feel that it is the editor's responsibility to make that decision.

Nighswander says the photographer should think about how the picture should look right from the start. "There are basically three times you can crop the picture, when you shoot it, when you print it, and when you send it to the back shop."

While they are shooting, photographers should be trying to make a picture that is as flexible as possible. "You can always crop tighter in the darkroom or on the picture desk, but you can't crop looser," Nighswander says. "You can't add information," once the picture is made.

"You really need to think, not only like photo-graphers, but like designers," he says. Photographers should be aware of the problems they can help solve by shooting with a variety of compositions. Nighswander says there's "nothing worse than having everything shot from the same perspective and in the same format (horizontal or vertical)." That takes away an editor's flexibility.

And he has a message to those photographers who are reluctant to think of themselves as picture editors. "Every time you shoot, you are exercising your opinion as an editor."

Carter isn't one of the reluctant ones. "Most pictures can be improved by cropping," she says. "Sometimes I will crop in the camera, and it is the most pleasing, but nine times out of ten it can be improved by cropping in the darkroom. I think intelligent cropping will improve the readership of the image."

Lennox McLendon, an AP photographer, also tries to think of the picture's optimal shape as he shoots. "You can create it in the darkroom," he says, "if you couldn't do it with the camera. But, when you're viewing through a viewfinder, you should be thinking this will make a tall vertical, this will make a good horizontal." Then, you make those adjustments on the easel. "You can correct a lot of things that you can't do in the camera," he says.

Burrows feels that too much cropping on the picture desk can take away from the photographers' message. "I'm in favor of less heavy-handed editing," he says. "You don't have to put your finger on every picture." Burrows suggests that an editor talk to the photographer before cropping a picture.

"The photographer had a special meaning when he took that photograph," Burrows says, "and you have to know the photographer and how he presents his pictures." He compares it to editing a story. "You have to communicate with the photographer about the crop. Learn

to ask what the photographer wants to say with the picture," Burrows says, "and if the photographer has a definite opinion about the picture, it is up to the photo editor to judge if the editing will add or take away from the photograph's message."

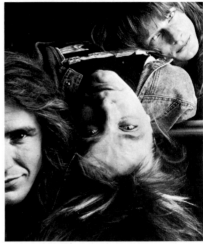

Burrows says every photographer has different feelings about the editing process. "Some don't care, others like to talk about the cropping," he says.

"Tastes are changing in composition and cropping," says Foster, who now works in the feature section at her paper. "Ten years ago, I would have never

Severe cropping and an eye for assembling the members of this Heavy Metal trio gives Wyatt Counts' picture a modern edge.

thought about cropping someone's feet off. Or I would have never used a picture where the horizon wasn't straight, I would have corrected it. Now I think tilted horizons, done right, can be real dynamic.

"Now," she says, "if it is planned and it works that way, it's a much more modern way of looking at things."

Nighswander takes a simple, straightforward approach. "I think you should crop out anything that doesn't add content or information, or mood. That's important," he says. "I know a lot of editors can't understand the importance of leaving any kind of open feeling. That's often what gives mood to the picture. Sometimes a little space around the picture can give you a feeling, even if it may be subtle."

Conceptual images, illustrations, feet cut off, dominant foregrounds, subjectivity as a personal style. The old rules don't always apply anymore when you're talking about style, composition and cropping.

Nighswander is not so sure that getting rid of the rules is so bad. He's for having guidelines, not rules, for dealing with content and display, because he says every day is a little different at a newspaper.

"I try to keep an open mind on all that because there are so many variables," he says. "If I was too structured in my thinking, I might limit myself when I go to put my page together."

Nighswander issues a challenge to newspapers that are too structured when he says, "I want to give my reader a variety of images. I don't want the reader to be able to anticipate what I will give them."

"You can't get yourself to where you are saying no to too many things."

NEWS:

Sensitivity, Thinking, Instinct – and Curiosity

Covering news assignments calls for a case of curiosity. Sensitivity. Some thinking. And instinct. Make that a lot of curiosity, thought, sensitivity and instinct.

David Longstreath says a college professor he studied with opened his eyes to one of the main ingredients you need to cover the news. Longstreath says the professor asked his class, "What makes a good reporter?"

The discussion went on for some time. Talk of equipment and training dominated the discussion. But, Longstreath says, "the bottom line was curiosity. That has always struck me." Longstreath says you can't go wrong if, as you approach a news scene, "you ask yourself what is it about this that is interesting."

Lennox McLendon approaches a news event and views it like a writer. "I try to come up with a lead from my viewpoint, and illustrate it with a picture," he says. "You try to get the peg," just like a reporter writing a story about the event.

Veteran photographers agree there is no way to be taught news coverage techniques. You really have to learn them by going out and doing it.

"Shooting hard news is like going fishing or hunting. You have to have patience," Longstreath says, "but you also have to have street smarts." There are no shortcuts to learning the news business. "There are no tricks, you have to work at it. Like playing the piano, you keep practicing, and practicing, and practicing."

Mark Duncan says your aim should be to "look beyond the obvious. Look for something more compelling with more emotion." AP photographer Eric Risberg agrees. He says sports and news are alike in that "with news, better pictures aren't always the main moments, but the moments after."

Ed Reinke also agrees with that approach. "In news, as in sports, reaction often brings the very best pictures. When the action is important, often the reaction is even more important."

Risberg compares it to sports this way. "We all look for the great play," he says, "but the best picture is sometimes after the great play happens, the reaction. By learning that in sports, you can carry that over to news. At news events, we often get the peak moments, but we should use the sports approach and look for the moment after the peak."

Risberg says the good photojournalist doesn't wrap up the coverage after the obvious pictures are made. He says the thinking photographer "will go back a few hours later, a day later, or a week later, when there are often different and good pictures to be made."

Part of that is looking for solid topics.

J. Bruce Baumann thinks that contests, and the books that are produced showing contest winners, are making it too easy for photographers to follow someone else's lead instead of finding their own issues and subjects to photograph.

For instance, Baumann says, if a big winner is pictures of poverty, several photo essays on the topic show up soon after. "Why aren't the quote, unquote, photojournalists in this country doing the research and going out and seeing what is the problem?"

Sandra Eisert believes contests are both good and bad.

"They help beginning people to have standards to measure their work," she says, "and give them a chance to see good pictures." But, photographers look at contest winners and "pick up these topics and they don't know why they are important, or why they are really shooting it," she says. "If you perceive the merit of the story and you shoot it, that might be a service for your readers," but if you just take the ideas and shoot them with no thought, she says, "all you are doing is recycling other people's ideas."

Jack Corn says some of that "recycling" may be a shortcut used by young photographers to move ahead. "They want to move upward, want to make more money, and get a better job," he says. "They want to do something worthwhile quickly."

But he thinks that slowly building your skills and doing your own projects is the way to get recognized. Corn says he always thinks of the old mountain saying, "What time builds, time respects."

"I think you've got a long life to live," he says. "You want to keep growing. Anybody can do one good story, it's the person who can keep shooting good stories that is valuable." And although he is now on the management side of the photo department, Corn keeps shooting pictures for himself to keep growing.

When you are on an assignment, Amy Sancetta says keeping on your toes pays off. "It's so important when you're at an event to be alert, to keep yourself so tapped in."

An empty chair at an honors ceremony serves as a symbol for human rights activist Andrei Sakharov in this picture by Amy Sancetta.

Sancetta had an assignment to photograph a ceremony honoring several human rights figures, including Andrei Sakharov. The stage was set with an empty chair for Sakharov, who wasn't allowed to leave the Soviet Union for the ceremony, and that was the obvious picture.

Everyone, including Sancetta, made it. Then the others left, but Sancetta hung in there. When the honors were handed out, Sancetta says, "they put his scroll there, and the best picture was the empty chair with the scroll, and the backs of the other honorees. It was just that little touch that made a good picture into a better picture." Sancetta, who was alone with the picture, called it "just a case of paying attention."

Longstreath says sometimes it's tough to pay attention. "When other people are talking or joking," he says, "it's better to bear down and think. And look at things, rethink your approach, and look again."

And use every tool and technique you have in your mind, or your camera bag, to help you make better news pictures.

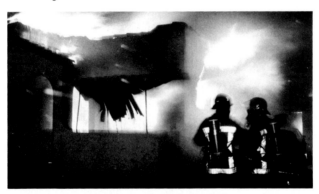

A slow shutter speed emphasizes the wind-whipped flames in this eerie fire picture by photographer Doug Pizac.

For instance, you normally want to use as fast a shutter speed as possible on news assignments in order to "freeze" the action. But, to show the fury of a fire fed by 80-mile-an-hour winds, Doug Pizac used a short time exposure to better tell the story. Pizac put his camera on a tripod, and made a half-second exposure to capture the intensity. Then he popped in a strobe to light the fireman.

A case of using the tools available - a slow shutter speed, a tripod and a strobe - to make an eye-catching, informative picture.

You have to use those tools wisely while facing a tight deadline, a seemingly impossible coverage situation, or circumstances that have you or your skills stretched to the limit.

Reinke cautions that there are boundaries to watch in news that don't exist in feature photography. "As for photojournalism, and I emphasize the word journalism, we make photographs from the circumstances we are given and we don't try to alter those circumstances."

And, when those circumstances don't work out as well as you had hoped, Bob Daugherty suggests moving along to the next item on the agenda.

"I guess you have got to avoid getting down on yourself," he says. "I have a thing I run through my mind when things are going badly: Try not to worry about that over which I have no control." He says worrying about a change in plan or a mistake in shooting can hurt you later. "If you're fretting about something, you're not going to be in the right frame of mind when the moment happens."

"You've got to avoid getting down after mistakes." The answer after you've had a mental or mechanical lapse, Daugherty says, "is to come back and do what you do the best."

Daugherty tells a story to illustrate his point about being calm and making the best pictures you can. During a long-ago presidential campaign, Daugherty nervously looked around a rally and jumped every time there was an outburst of applause or a reaction in the crowd.

Veteran UPI photographer Frank Cancellare, also on the assignment, looked over and said, "Kid, you can't shoot the sound." Daugherty calls it some of the best advice he ever got. Do what you do best. Make pictures when there is something to make pictures of.

Hard news often isn't pleasant. Many times you're working in an explosive atmosphere. Someone may have been injured or killed in an accident, people may have lost their life's work in a fire, or opposing groups may be emotionally charged.

It's a heavy pressure. The pressure to make the best possible picture, balanced with sensitivity toward the people in your pictures, measured against the thin line of involvement by the photographer.

Risberg says he depends on his instincts as he quickly sizes up a news scene, and tries to find a middle ground. "News is the most instinctive one for me. It is really challenging. You can't really prepare for it, you've got to rely on instinct."

Much of the news that Risberg covers in San Francisco includes large demonstrations that can shift quickly. "A lot of the protests turn ugly. I rely on instinct and try to position myself where I'm not so close to the action that I get involved in it. I try to find a middle ground."

Risberg also advises, "When I'm doing news, I travel light and don't shoot too much film. I try to think, and not get caught up in the event. I distance myself."

But AP's Jeff Widener takes a different approach.

During his coverage of the student rebellion in China, Widener at one time or another used every piece of gear he had. "I carry more gear than I need, probably out of insecurity. I'm going to look like a hunchback by the time I'm 50," he says.

Yet, when it came time for what would be his finest picture of the assignment, Widener took the simple route.

In order to make his photo of the lone Chinese student stopping the column of tanks, he found that just getting into position was tough. Widener first packed a

400mm lens, a camera body, an extender and some film into the pockets of his jacket, then biked across Beijing to a hotel overlooking Tiananmen Square.

"I was kind of shaken up," he says. "There were stories about people being killed. I was scared." Widener passed military patrols on the way. "You could hear gunshots."

When he got to the hotel, he enlisted the aid of an exchange student staying there to find a route to the upper floors of the hotel. After making some pictures, and rounding up an additional roll of film from someone in the hotel, Widener saw the lone man approach the tanks. "I froze, and I thought 'this guy is nuts.' But I guess with everything else going on, it shouldn't have seemed unusual."

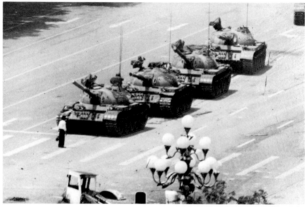

Widener made the pictures in very low light. He remembers thinking, "I've got to gamble." The exchange student biked the film back to the AP bureau and Widener checked with them later. In the excitement, he had

Jeff Widener perched in a hotel window and could not believe what he was seeing as a lone man approached government tanks in Beijing.

loaded ASA100 film, but thought he was using ASA400 film. His exposures were off, but "one was usable." Widener remembers the scene. "I was a bit rattled. I was really scared the whole time. There's no use being macho about this."

But he had the picture, which an Italian photo group promptly labeled "the photo of the year." Widener thought at the time it was a good one, but "I didn't dream it would get the response it got."

McLendon takes a shoot-first approach at times. "If it is a breaking news event," he says, "where you don't have time to think it out carefully, my first inclination is to walk in and shoot what I see. Then I try to back off and think about what is happening, what is the news peg? Sometimes that is where you tend to make your better picture." McLendon says he will sometimes shoot more film than other photographers, but often, "my last few frames is where the picture is."

AP photographer David Breslauer says its a matter of finding the right spot, which he calls X. When working with young photographers, Breslauer says, "I try to convey the importance of place. Not only of what you're shooting, but where you are shooting it from. If you can find the X," he says, "you've found the best possible place to make your photographs."

Sometimes that means moving away from a position that has paid off before. Breslauer's Austin-based assignment includes extensive work in the state legislature. Usually he works the floor, looking for illustrations for the day's stories.

He says on a slow day, though, he'll look for "things that are unrelated to the news of the day, but are interesting in the context of state government. Rather than shooting from my normal place on the floor," he says, "I'll go up to the gallery and watch things happen."

That move can provide a picture when lawmakers gather around a colleague during a session "and have him surrounded" while discussing a proposal. "I never could have made that picture on the floor," Breslauer says. And, the picture is interesting, "not just because of who is in it," he says, "but the pattern of the people around the lawmaker seated at his desk is interesting visually."

Sometimes the X is in the most obvious place, despite some quick thoughts to the contrary.

While covering a visit by President Jimmy Carter to Bardstown, Ky., Daugherty fought off the urge to wade into the crowd and a few minutes later made a classic campaign picture from the photo truck.

Daugherty says it had been a bad day on the road. No good chances to make any pictures. And it looked like it was getting worse. A few blocks into the parade, Carter got out of his car, Daugherty says, but "his back was to us. My first instinct was to

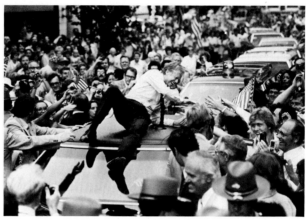

Photographer Bob Daugherty "stayed the course" and made this classic campaign picture of President Jimmy Carter during a parade in Bardstown, Ky.

jump the truck. Try to get into the crowd and get close. But I stayed the course, I stayed on the truck."

Carter quickly got back in the car, traveled a short distance, then got back out of the car. "He got out and hopped on the hood of the car," Daugherty said, and the photo truck was in the perfect position to make a clean picture as the crowd reacted.

"It was not until then that I realized that I had made the right decision to stay with the truck," he says. "Sometimes you have to give up one chance, and then you get a better one if you stay with your plan."

Daugherty says actually making the picture was "very simple. I chose one camera and one lens, an 85mm. It gave me some atmosphere, and it gave me the speed to overcome some bad light." The picture is one of Daugherty's favorites.

Reinke says any job is going to go better if you're prepared. "The people who plan best from the get-go

make the most out of the situation. I can't think of a situation that planning is not going to improve your chances."

"Pictures of tornadoes, for example, are made by people who have film in their camera. That's no time to be trying to load. A fire, a convention, I really can't think of a single situation," Reinke says, "where planning won't pay off, not one. Sometimes you have to alter those plans but you're in a much better position to alter a plan you have already than when you have no plan at all."

Preparation is an everyday thing, he says. You never know when you're going to have to hit the ground running. He checks his gear quickly every day. "I never leave gear in the car or in the office, so I handle it at least four times every day, at least from my house to the car, and from the car to the office, and back again. I'm always checking straps for wear, and the general condition of the gear. I always have a spare nicad in my bag. I always have a set of fresh AA batteries in my bag. I figure I can't do much without a functioning camera."

And that daily preparation should include reading the newspaper to know what is going on in the world, and your community. Not just the sports pages, but the local section so you'll know the topics and people if you're sent to the city council meeting.

One of a photographer's most important pieces of equipment, Breslauer says, is a telephone. "On any level, you can take care of getting a lot of pictures made by working the telephone. You can save yourself steps at the other end" by getting preliminary planning done on the phone.

Breslauer illustrates this by describing an assignment he had - shooting the 100th anniversary celebration for the Texas state Capitol. Rumors were floating around about a massive fireworks display, but it was tough to pin down the facts.

Breslauer says "we hit the phones, and eventually found out where they would be launched and how high they would explode. We were able to position ourselves to make the pictures because we were able to do a lot of legwork from the office. We knew where the X would be to make our pictures."

Longstreath, after covering several news events, came up with a mental game he plays. It's called "what if?" It's a scenario development exercise he runs through to help him make order out of chaos at a news scene. It helps him calculate his options.

"As the years go by, you add experiences to your data bank. It's kind of a mental game you play where you try to anticipate what is going to happen."

Longstreath used the exercise while covering a hostage situation in a convenience store. He set the scene in his mind - "a man is in the store, he has a hostage." He then looked at the options - "Police could storm the building, he could surrender, he could come out shooting, he could come out with the hostage, he could kill himself in the store."

By studying the situation, Longstreath was getting his game plan in hand and deciding how to cut down on the chances of missing something. He ran through a list in his mind, and then told himself to get a long lens ready. "I better use this lens. If this thing gets going, the adrenalin will be pumping, so get a tripod."

Photographer David Longstreath studied this scene and readied himself for the moment when a hostage situation in a grocery store would end.

He took that precaution so his pictures would be rock steady despite the excitement.

And, he wanted to have long glass to use without being burdened by it if he needed to move quickly. With the lens on a tripod, he could leave it easily and move with the situation. "If I needed to move fast and use a short lens," he said, "I wouldn't want to carry it (the long lens)."

He got himself ready, "set up the f-stop and shutter speed to allow for motion and for depth, put in a fresh roll of film, and waited."

When an armed gunman walked out, Longstreath was ready and captured this sequence as a police SWAT team went into action. The whole scene unfolded in a few moments but Longstreath's planning gave him a selection of pictures.

"Two hours later, the gunman ran out the door," Longstreath remembers, "and I pulled closer to the camera, hitting the button. When I saw him raise the shotgun, I had no doubt they were going to take him out." As Longstreath watched and kept the camera rolling, "the police shot him. At four frames a second, I got 19 frames of him before he hit the ground." The whole incident had come to an end in a few seconds.

Longstreath's thought and preparation put him in the position to make dramatic pictures of the brief, but violent scene. The "what-if ?" exercise had paid off. And, because of this situation, he has more information for his "data bank."

Duncan also has been in news for several years, including a stint in the Department of Defense news pool during the Persian Gulf troubles.

During that assignment, he was taken to a Navy ship that had captured several Iranians and a boatload of mines. Duncan knew what he would be seeing, but didn't know how it would unfold. Like Longstreath, he prepared himself for any type of situation by running through a list in his head and making sure he was ready.

"I made a conscious decision about what I should take with me in the way of gear," he says. "I only took four lenses, including a zoom, and I carried three cameras."

First, he would see the prisoners. "I loaded 400 film, put on the strobes. I knew I was probably going to shoot hard flash, and ended up doing that. I had a wide angle and a zoom on for the most flexibility," Duncan says.

Captured Iranian gunboat crewmen are held on a U.S. Navy ship in this picture from the Persian Gulf by photographer Mark Duncan.

He didn't know how much time he would have, so he worked methodically. "I tried to shoot an establishing shot first and then went into a tighter situation to isolate the captives. It was over in three or four minutes, but it seemed like a lot longer."

Duncan only shot about a dozen frames, saying he "tended to be a little more careful about what I was shooting. I have found that when you shoot a lot of film in a short amount of time, you tend to have a lot of duplication. I would rather have 12 frames with two or three good pictures, than 36 frames with only one good

picture." All of this was almost automatic to him. "This was all reaction at the time," he says.

Later, when Duncan learned he would be transferred to a smaller boat to go out to the Iranians' gunboat, he left one of the cameras and a lens on the command ship so he wouldn't be completely without equipment if the small boat got swamped.

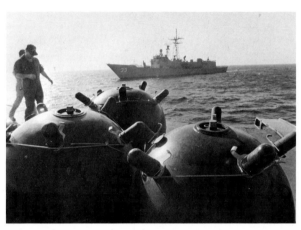

Mark Duncan was so busy making pictures he didn't have time to be afraid of the mines on a captured Iranian boat in the Persian Gulf.

As he made pictures of the Iranians' boat loaded with the mines, he didn't really worry about the danger. "I don't believe that a camera is a shield, I was just too busy to think about the danger. I was totally concentrating on making the pictures."

Duncan's thorough coverage was on front pages of newspapers and magazines all over the world.

Longstreath's "data base" paid off again at a funeral for tornado victims in Saragosa, Texas. The tiny Mexican-American town was emotionally rocked by the high death toll in the storm.

Another funeral, for victims of the McDonald's massacre near San Diego in 1984, gave Longstreath some ideas about how the Spanish-speaking Catholic service might go.

"I remember watching all of the photographers around me, shooting roll after roll," Longstreath says of the Texas funeral. He kept looking around, but found "I wasn't missing anything, nothing was happening."

Longstreath broke away from the pack. "I worked myself into a position near the caskets," with the mourners in the background in view. The lessons learned years earlier began to pay off. "I knew at some point there would be a 15- to 20-second display of grief. I remembered the intensity of that situation, and it happened again."

The mourners approached the caskets at the end of the ceremony. "They stepped up, and boom, it happened." Longstreath quietly made his picture. "It symbolized the loss. You can show broken buildings and twisted trees, but people relate to a picture of people, how they react to a loss. It said everything," and the thinking ahead had paid off with a sensitive photo.

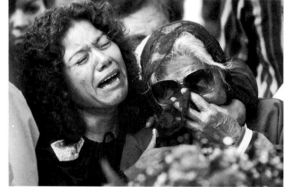

Photographer David Longstreath was ready for the brief, emotional outburst by these mourners at a funeral for tornado victims because he had covered a similar situation a few years before.

Sensitivity is important.

Like the instinct for news, experience is the best teacher. Longstreath says those first times at an accident scene, or other news event, are tough. "They're crying, their child is on the ground. There is only one way to learn that," he says of working in that situation, and that is "to be there."

Rusty Kennedy tells of photographing a coal miner resting for a moment after finding others dead after an explosion. The miner, who had gone into the mine with a rescue team, was gathering his thoughts before telling the families of the trapped men that the miners had been killed. It was a quiet moment. Kennedy explains, "I made the picture with a long lens from some distance. I

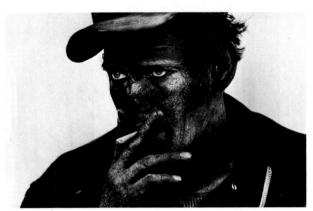

A miner relaxes for a moment with a cigarette before telling waiting relatives that several miners have been killed in an explosion, in this picture by Rusty Kennedy.

didn't have to intrude on him. I was able to make it, but he was never aware of me."

"Photographers sometimes get a bad name," Kennedy says, "and we earn it. Sometimes it's a real ugly scene when we intrude."

McLendon says it makes a difference in sensitive situations whether other media are present. "If there is no media around, it makes it a lot tougher," he says. "When I'm out there by myself, I try to identify with them. Sometimes I'll back off and use a real long lens to separate myself." McLendon finds that people sometimes react differently when there is a photographer around. "With some people," he says, "it doesn't make a difference, with others it does. The photographer should be sensitive to that."

If other media are there, McLendon says you can more easily avoid aggravating the situation. "You can try to blend in and back off where you're not intruding as much."

Even when it's not a sensitive situation like a funeral or accident scene, photographers can intrude on the subject's personal space. It can be during the arrival of a celebrity at an opening, or a famous personality going home from the hospital, or someone on trial leaving a courthouse.

"Too often, we have that 24mm lens on the camera," Larry Nighswander says, "and we've got to get in tight. I

don't think we do it intentionally to intrude on people, but I know if I do that I'll have a dominant foreground. But, sometimes you have to think, is that worth intruding for?"

Nighswander thinks the number of people covering the news, on some events, also affects how close a photographer will approach a subject. Sometimes, he says, "if you are going to have one large turnout, you're afraid you'll get blocked, so everyone goes wide and gets in tight."

From outside the pack, "all you see is a sea of photographers. If we could all back up a few steps and make some room, we could use a 105mm lens and get a better picture." Nighswander doesn't see that happening soon, though. "We're all insecure and we're all afraid we're going to get beat," he says, so the wide-angle lenses stay on the cameras.

Daugherty questions what he calls "driveway journalism," staking out a newsmaker's house.

He's concerned that the presence of photographers and other news people at the subject's home is an unfair pressure on the subject's family. "They aren't accused of anything, but unfortunately, when you show up at a man's house, an innocent man until proven guilty, never mind what it might do to the man, think

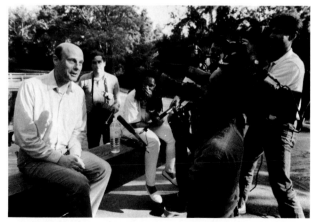

Photographer Bob Daugherty questions if "driveway journalism" is fair to the subjects and their families, like suspected spy Felix Bloch in this picture by photographer Juana Anderson.

what it does to his family in the community. That's where I have a little problem."

"I'm not shy, but it doesn't take much to put yourself in his place, it could be me. You are in front of one family's home creating an atmosphere that doesn't normally exist there ."

Reinke says he's changed over the years. Coverage of a bus crash, and the followup to the accident that killed two dozen youngsters, was tough for him. "When you have two kids of your own, a story like that begins to wear on you."

"In the beginning it was a great deal easier," Reinke said of his early days in the business. "When my camera was in front of my eye, I was going to squeeze the button until somebody stopped me or I had enough." That's changed for him though. "I think that my tendency now is to not invade privacy as much as I once might have."

"I really felt grieved out at the end of it (the bus crash coverage). A full week of cemeteries, churches and funeral homes, and so much mourning. I had come to the end of my line on what I could take," he says. "The answer is to take a few days off and hold my own kids and think about how fortunate I am. That helps."

Ed Reinke made his picture of this tender moment at a memorial service for teenagers killed in a bus crash while returning from an amusement park. The week of funerals, memorial services and grief were tough on the veteran photographer.

"Still, I think that grief is one of the most difficult things to photograph," Reinke says, "and each photographer has to draw their own personal lines on what space they will tread on, and where they'll stop. Should I have, or not? You need to make those decisions on your own."

While covering a mining disaster in eastern Kentucky,

Reinke talked quietly with the trapped miners' families at the scene. "It was a case of getting to know the families," he said. Reinke had worked to secure their trust by being open with them, asking when he could make pictures, and being helpful when they needed a hand with something. Later, they invited

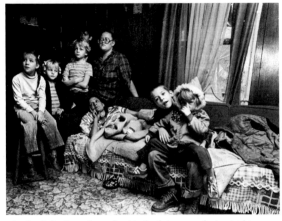

A miner's family gathers after his death in an explosion in this picture by Ed Reinke.

him into their homes, to the church services and to the burials.

Reinke says the decisions come quickly, almost automatically when the scene is unfolding in front of you. "The breaking spot news, like Stanley Foreman's pictures of the kids falling from the fire escape," are handled by instinct. "He didn't have any choice but to make those pictures. You make them because it is happening so fast you don't have time to think about it."

The tough ones, Reinke says, are "the ones you have to sort out in your mind, the ones you don't have to make."

FEATURES:
Seeing the World Around Us

Features. Seeing something that others don't see. Bringing a slice of life to the readers. Making something special out of the ordinary.

Ed Reinke calls feature photography "seeing the world around us." Reinke, who is one of those photographers who can go out and bring a good feature home when others struggle, says "I'm not sure it's an insight into life, it's that I'm willing to watch things unfold."

He's patient. "I'm willing to wait three or four hours to make a good picture of a mundane scene. With planning and patience, you can make a silk purse out of a sow's ear." Or at least a humorous picture of some hogs cooling off in a mud hole to go with the day's weather story.

And Amy Sancetta says "the best ones seem to be the ones you never thought would be out there."

Reinke says photographers should make feature pictures that people can relate to, so they'll say, "I remember when I did that when I was a kid."

He continues, "Feature pictures really elicit a response from the public. You have to realize that most people never get their picture in the newspaper, and when they do, a good percentage would rather not. When we can go out and make pleasant pictures of people doing things that are interesting, it's a plus for the people we serve."

But Alex Burrows isn't so sure of the stand-alone feature picture's place in the newspaper. "Newspapers should try to get away from stand-alones and make pictures pair up with stories more."

Burrows says editors at his newspaper, the *Virginian-Pilot* in Norfolk, "have come to the conclusion that this is not what we want to do. We want to have pictures run with stories." Burrows says his paper "rarely has one on the cover," and if it plays a stand-alone feature at all, "it's usually inside."

George Wedding doesn't completely agree with Burrows. "I think that feature pictures of people going about their daily lives play an important role in the newspaper," he says.

"I think we are a newspaper, first and foremost, and our goal is to have photographs to reflect the news of the day whenever possible. When it is possible," he says, "they are tied to stories, but they don't have to be. There is a place for feature photography."

"The best feature pictures are a photographer's observations," Wedding says, "and they offer us views of ordinary, common events in the lives of ordinary citizens, and sometimes, but more often than not, they are how we get good news into the paper."

Wedding says the good feature photographer "becomes a student of people's body language, and facial expressions, and reaction to their environment. And the photographer documents that."

When Larry Nighswander was the picture editor at *The Cincinnati Post*, the staff called feature pictures "the citizen of the day."

"They like to take an average Joe and make him a star for the day," he says. "Something funny, outlandish, a juxtaposition, a relationship or a lifestyle that people aren't

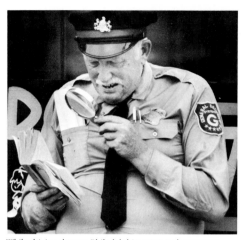

While driving down a Philadelphia street on her way to another assignment, photographer Amy Sancetta spotted security guard M.C. Rosenberg reading a book at a bus stop. This kind of "wild art" is welcomed by some editors, criticized by others.

aware of. You're giving a reader a chance to be a star for the day." Nighswander says "those are the ones that people cut out and put on their refrigerator, not the news picture but the quiet feature. People like to step back and just enjoy their community."

But J. Bruce Baumann says, "It just can't be a pretty picture. They really don't have any place in newspapers. That's not to say there aren't good feature pictures to run," he says, "but they need to express some kind of information that is useful."

Sandra Eisert takes the approach that a good feature picture is welcome, but that it is a rare find.

"Feature pictures aren't a bad thing, but there are so many bad feature pictures that it's easy to throw up your arms and say that they are all bad," she says. American newspapers "publish 3,000 or 4,000 bad ones for every good one, and that's not a good ratio."

But she thinks there is a danger in having a flat prohibition against features. "I wouldn't want to give up the really good pictures. They do add a dimension to the newspaper, but they are really hard to make." Part of that difficulty is finding good subject matter, she says, and part of that is how newspapers approach gathering feature pictures. "We've got our visual standards and we've got our news standards, so we are crossing a lot of things off the list." Too often, the feature picture is the only thing left, and that gets the bad ones into the paper. Eisert calls it a "system of desperation. It doesn't give us the results

we want."

Jack Corn thinks newspapers would be dull without features. "If we just illustrated stories, it would be boring," he says.

But feature pictures won't always be contest winners. After all, he says, "you don't get great news pictures every day. We come up with people being people and it is hard to do, but we have come up with some great pictures. I wouldn't argue that this is better photography than something else - news or sports or something - but it all fits together to make a complete package."

Corn also believes that feature pictures draw readers into the paper. He has a couple of photographers on his staff who regularly contribute good features, "and they get as much mail as a columnist."

Reinke's picture of a farmer painting his barn in rural Kentucky showed a typical country scene, a chance to take that step back and enjoy. The photo was made interesting by the choice of angles and lenses. But, it didn't just happen.

He found it "the way that I find 90 percent of my feature pictures. I was driving down a road and saw a new barn with a ladder, but there was no one around. I knew someone was going to paint that barn, so I went on 15-20 miles, and had an iced tea. Then I came back down the road and the farmer was painting."

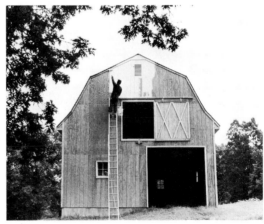

Photographer Ed Reinke spotted the setting for this country feature but the painter was missing. Reinke went on down the road, returned later, and made this feature of a Kentucky farmer painting his barn.

Reinke talked to the farmer about his new barn, got the man comfortable with him being there and "about two hours later I made the picture just the way I wanted it."

Baumann thinks that may not be a good investment of time. "Rarely will a photographer just 'find' a picture. That kind of aimless, directionless photography doesn't have a place." Baumann says when you look at salaries and car expenses, "it's a waste of resources to have them go out there without any direction." He says photographers should find a good topic, research it, then shoot it. "That offers a lot more opportunity for pictures with content."

Reinke thinks there is a place for feature pictures without always having a news peg. "I don't think pictures have to be prize winners to be good. Making pictures for that day's edition is what we are paid to do, a nice picture on a slow day."

Rusty Kennedy also enjoys features, but he especially likes long-term projects that have some depth, the kind of feature photography that Burrows and Baumann advocate.

Kennedy once spent "a couple of months, maybe ten hours a week," visiting a group of homeless shelters and photographing the people that lived in them. Kennedy said the project started almost by accident. "I was down in that area on another assignment and saw the people sitting outside. They shouted to me to 'take my picture' and I started to talk to them. They were interesting people."

"I started going down there, started wandering around." The project, which was shot several years ago, was an early glimpse at a growing national problem. "They were homeless," Kennedy said, "before people really talked about that."

Kennedy took pictures with him each time he visited, but "they never were really interested in seeing the pictures. More the attention of me having interest in them." That project "made ten good pictures. That was

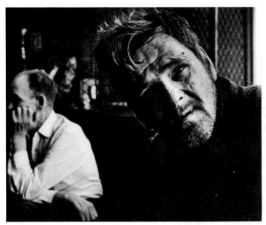

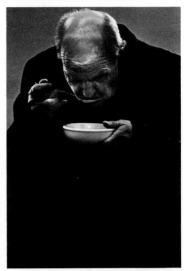

Photographer Rusty Kennedy likes features with some depth. Kennedy spent a couple of months visiting a Philadelphia homeless shelter and made a series of sensitive portraits of the people who lived in the facility. This project was done in 1974, years before the homeless became a popular topic.

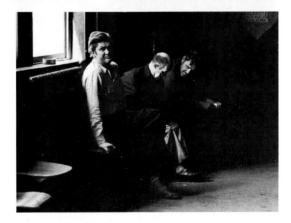

one of the favorite things that I've done. It had some depth. So much of what we do is for the moment."

Eric Risberg also prefers the feature package.

Risberg uses much of his time preparing himself for the assignment. "I approach them with lots of research. I'll go out, spend a day, try to find out everything I can about the subject. And I'll keep going back after the initial shoot to fill in any gaps." Risberg tries "taking a second, or a third, or a fourth look at things" to round out his stories.

He used this approach for a package on bike messengers. "It started out where I just hung out at the office and saw them dispatched, taking that time to understand the operation, meet people. Then another day I actually did the job. I got on a mountain bike and rode with the messenger and I got to see the little alleys and streets."

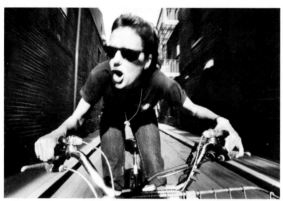

Photographer Eric Risberg brought the reader into the world of the bike messenger by mounting a camera on the basket of the bike and setting the camera with a slow shutter speed to give the feeling of speed.

That made an impact on his package, Risberg says. "By doing what they do, I saw a neat little alleyway. I came up with the idea of putting a camera on the handlebars with an extreme wide-angle lens to come up with a real intimate view of a messenger going through the alley." Using a slow shutter speed, Risberg made a picture where "you see the face, and the walls going by." It turned out to be the lead picture.

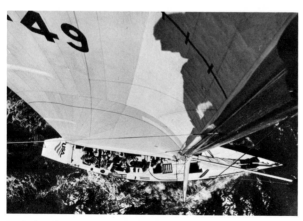

Perched on the mast in a bosun's chair, Eric Risberg made this overall view of an America's Cup entrant at full sail in San Francisco Bay.

"It was a success because I was involved," Risberg says, "and that also is true of the sailing package," a set of photographs on a San Francisco-area entry in the America's Cup competition. For that package, Risberg sailed with

the crew four times, including one sail where he worked as a grinder on the boat. "I didn't make any pictures that first day, I just took notes and did what they do, and came up with ideas."

Risberg went back out again three times, making pictures on those trips. "For that package I wanted a unique view of what they were doing, the boat and the men."

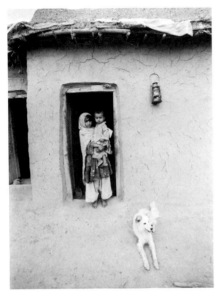

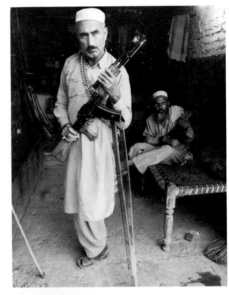

Photographer Jeff Widener worried that this package of pictures on an Afghan refugee camp wasn't working as planned, but he kept shooting and honing the take and the result was a solid set of photos.

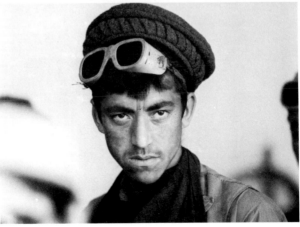

Risberg wanted one picture that captured the whole story. "I thought I could do that by putting a camera on top of the mast looking down, but I couldn't get it to work. So, I agreed to be at some risk and I was hoisted up to the top in a bosun's chair."

Risberg had one hand on a guide wire and one hand on a camera, but despite the danger he thought it was more than worth it. "That picture summed it up. It showed you a different view of the boat, and got the point across about all of the men it takes to run a boat like this and the teamwork involved."

Jeff Widener's base in Bangkok gives him a good spot to work from to shoot a wide variety of packages.

While working on his package on Afghan refugees in a camp in Pakistan, Widener said he was discouraged in the early going. "I was worried," he says. "Sometimes when you first start, things don't work, but then they begin to click." Widener found a small photo store in a nearby town where he could get his film processed and small prints made, "editing as I went along." Each day he sought to fill in the gaps. "You have a general idea what you need, your main photo and your helpers."

For a package on a slum village near Bangkok, Widener says he kept going back to get better pictures. "Over a three-month span," he says, "I was shooting and shooting and shooting, looking to see what was missing, then shooting again." He says he shoots a lot of film to get the pictures he wants. "It's not like I'm going out and shooting a couple of

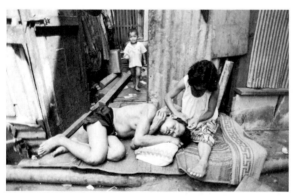

This poignant scene in a slum village near Bangkok is the type of personal picture that photographer Jeff Widener pushes himself for. Widener believes that you keep shooting and editing, then shooting again to fill the gaps.

rolls of film and getting those six pictures. But I guess no matter how much you shoot there is only going to be one best picture."

Not all feature assignments are shot over a long period of time, or have an exotic dateline. There are the daily needs to fill, like Reinke's barn painter, and others. Even then, a little thought goes a long way.

 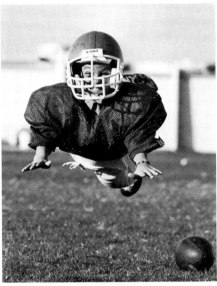

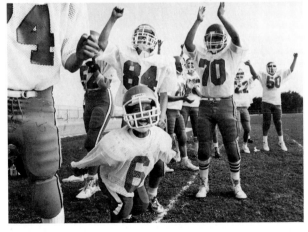

Photographer Lennox McLendon spotted this young football player while shooting a picture for a series on special education. He returned to the school to round out the package on the young player who made up for his lack of size with enthusiasm.

Lennox McLendon takes different approaches, depending on what type of feature he's working on. If it is

a single picture, McLendon says he approaches it by "trying to sum it up, putting the elements together in a single image. With a package," he says, "you want a beginning, a middle, and an end, just like a reporter would write a story."

McLendon thinks about feature pictures as he drives to assignments. And, when one isn't working out as well as he had hoped, "I'll stop shooting and try again another day. You can do that with features."

Even after he's shot a single feature or a package, he sometimes sees something missing and returns for more pictures. "I've gone back, after thinking about my shoot, and redone the job. I always think there was probably a better way to do it," he says. McLendon feels the extra visit goes better at times because "now you know where all the elements are."

Sancetta says it's sometimes easier to have an idea in the back of your head, even when cruising for a daily feature. "I try to have something out there to aim for." She adds, "When I do go out, I try to have spots that I head for - a park, a pool. Once, I looked up in the phone book a place that makes ice to make a feature to match the hot-weather story."

"You can drive around and never find anything," she warns. "It's nice to have some goals or you'll find yourself really frustrated."

David Breslauer subscribes to Baumann's theory about researching an idea before going out. He reads the newspaper for ideas. "A lot of times before I go out, I'll read the paper first to find something that might be interesting."

Feature ideas can come from anywhere. "Something will come in the mail, or I'll see it in a paper, the secret is to be well informed. But, that's true of everything we do," Breslauer says.

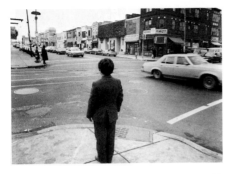

Photographer Amy Sancetta spent several months documenting the recovery of a young Armenian boy who was being treated in a Philadelphia hospital for injuries suffered in an earthquake. Sancetta's pictures followed the youngster from his arrival in America, through his rehabilitation program, to his acceptance of American ways including car magazines, sneakers and bubble gum.

"If the feature has some kind of peg," he says, echoing Baumann, "you can make it more than a filler on a newspaper page. Also, if you have a chance to think about the feature, you have a chance to be in control a little more."

"There are times when you're out and you'll see something, and you say I better stop now cause I'll never see that again. But generally I feel I'm more productive if I leave with something in mind," Breslauer says.

AP photographer George Widman agrees. He says his feature hunts are "a mix, cruising and something on my mind. It's a lot harder to find a feature when you have nothing on your mind." Widman says he also tries to think of a peg - "What's the weather? What's the news? It's not always easy to make a feature that has any relevance."

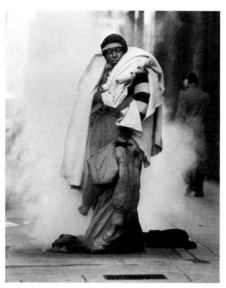

George Widman's study of a homeless person on the streets of Philadelphia is an example of a feature picture with a message.

But his picture of a homeless man standing over a steaming grate to keep warm a few days after Christmas was extremely relevant. "The key is the date," Widman says. "Campaigns for the homeless always stop after Christmas."

He remembers that "it was a really cold day, and these guys are still there. They didn't go away with the Christmas wrappings." Widman shot the picture and "I talked with him, tried to get him to go to a shelter, but he refused." Widman said it was a tough shoot. "I used a 180mm, at a 60th wide open, and I was shaking because it was so cold."

But the picture worked, and was widely displayed. "It was very early morning light, gold light, and the business person walking by in the background put it all together for me."

At the Exxon Valdez oil spill in Alaska, John Gaps III was assigned to take a feature look at the situation, weeks after the hard news angle had worn off.

Gaps wanted to make a picture showing the effect of the oil on the fish and vegetation under the surface. He thought back to a picture he'd seen in college of a diver entering the water. It had been made by partially submerging a camera, using a fish tank as a shell.

Gaps thought "this might work. I went to the pet store and bought an aquarium, and carried the thing for four days. I tried it once and it didn't work because there was too much oil. So, a couple of days later I was out on

an island and it looked like a better situation. I got down in the water and balanced the aquarium on a rock."

"I had to get the camera as far back as possible from the glass to work," Gaps says, "since the tank's glass worked much like a ground glass in a large-format camera. I was actually shooting the glass." Gaps used a 24mm lens and made a series of exposures.

Getting a usable density on the film was tough. "It was overcast," he says. "That was a prerequisite for doing it to get the exposure in a usable range. I tilted the camera down for an exposure reading in the water, then up to meter the sky, and I split the difference. It was about a three-stop range." Gaps shot the scene of underwater life and men working on the shore at f16 to get the depth of field he needed.

To show the cleanup efforts after the Exxon Valdez oil spill incident, photographer John Gaps III sank a fish tank and positioned his camera to show this split-level view.

Even with all of that work, there was some frustration. "It wasn't exactly what I wanted, but I didn't think it was going to get any better," Gaps says.

Gaps also has followed the continuing story of farm problems in Iowa. His picture of a farmer walking through the parched fields is a look back at the Farm Service Administration documentary style.

The Des Moines-based photographer says a lot of preparation and thought goes into that kind of picture. "Before heading out on these trips," Gaps says, "I talk to the county agents to find the places that are really bad." That gives the photographer a better chance of finding the right picture to go with the story.

Then, he says, "I always approach them like a reporter would, asking questions and making notes, and talking with them." He adds that blending in is important. "I try to mix with the people, dress for the job, and I never try to act like I know exactly what is going on. I let them tell me. Usually, I learn more than I knew anyway."

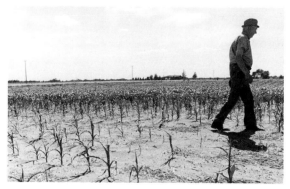

An Iowa farmer walks through his drought stricken field in this picture by photographer John Gaps III. To make the picture, Gaps would squat and make a few frames, move to another spot and repeat the process until he had the frame he wanted.

Patience, like Reinke teaches, is also important. Gaps' visit with the farmer wasn't his first time out in the fields that day. "He had been the fourth guy I was out in the fields with. We were walking through the field, and every once in a while, I would squat down and make a couple of frames, then keep going." As they walked, Gaps let the farmer describe the problems he faced.

Sometimes the good pictures aren't obvious. "I didn't realize that was the best one," Gaps says, "until I got back and looked at the film."

Reinke says there are no rules for feature photography when it comes to equipment or film. "It's whatever the situation warrants. As a general rule, I like to make feature pictures on the slowest film possible, but sometimes I'll use ASA1600 film in the fog to bring up the contrast and give the picture a certain effect."

Nighswander says that when he was a photographer, he used long lenses to keep from being spotted. "I found myself using telephotos 80 percent of the time," to control the depth of field for cleaner pictures, and most importantly for obtaining candid pictures. "As soon as the photographer is spotted," Nighswander says, "the spontaneity is gone."

Sancetta agrees you use what you need, and thinks the simple approach is the best. "I try to do things as simply as possible. You can gizmo yourself right out the window."

Reinke explains that "ours is to interpret what we see into a mood or feeling. You have to choose whatever lens and film that allows you to do that."

"Feature photography is a prime way to step back and enjoy life, the quiet moments," says Nighswander. "In our rush to report the news, we sometimes overlook what the reader wants. Every editor in America needs to evaluate that."

SPORTS:

Peak Action & Telling Reaction

Sports photography. Dreams of the Super Bowl, the Olympics and the World Series. But reality is oftentimes a high school football game, the college team down the road, or Little League baseball in the summer.

All of those events, from the biggest to the smallest, are important, though, since readership surveys show a large number of newspaper readers get the paper for the sports section.

Rusty Kennedy remembers when sports weren't that important. "Sports was not that big a deal 20 years ago, but now sports has gotten to be such a tremendous influence in our business that any photographer for a newspaper or a wire service has to be able to shoot sports."

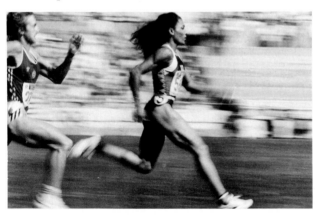

Peak action, or telling reaction, are what you strive for. A different picture, if you can. Not just settling for the obvious.

Ed Reinke says the picture you want is simple. There is "no question it is

Lennox McLendon used a slow shutter speed and panning technique to give the feeling of speed to this picture of Florence Griffith-Joyner in the 1988 Summer Olympics in Seoul.

the peak, story-telling action. It's just that simple. There is peak action, then there is the story of the game, but the picture that works best is the one that incorporates both. That's the journalism part of sports photography."

"It's not good enough to make a picture if it doesn't mean anything. There was a time, when I was starting out in the early '70s, when it seemed you could aim your camera at second base and just wait for the play to happen," Reinke says. "Now you're looking for peak action and the picture that tells the story. Sports is no different than news in that the best product we can offer is the perfect marriage of the action and story."

Part of that is simply paying attention. Kennedy tells of the time he just watched the struggling pitcher in action, looking for something odd that might give him a picture in a dull game. Fearing he would miss something if restricted to the narrow view of the camera, "I watched without having the camera to my face and I spotted his hat falling in front of his eyes when he'd have a hard follow through."

"Then I trained the camera on him for a few pitches and caught it," Kennedy says. He had his different picture.

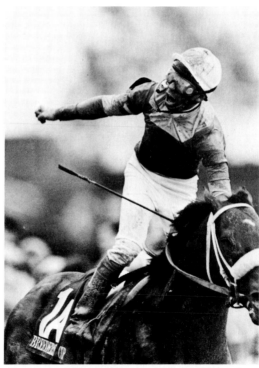

Photographer Ed Reinke didn't drop his concentration as the winning horse crossed the finish line and caught a jubilant Angel Cordero celebrating his victory in a mud-splattered race.

He warns that it's easy to fall into a rut covering baseball, or any sport. "We are sometimes in a formula

kind of thing, and don't look for the odd picture. Sometimes newcomers will make a better picture because they aren't locked into that formula journalism."

Eric Risberg says you have to fight the pattern of going out to a sports event, no matter what it is, and working from habit. He says the best approach "is to not always go to the same place. Try other spots for variety. By moving around a bit it helps you keep your enthusiasm and interest up because you're looking at it from different perspectives."

Like Kennedy, Reinke also likes to watch the pitchers, hoping for something different. And it has worked for him, too. "This was a simple matter of knowing I could commit to staying on a pitcher. I was going to make a picture of the pitcher getting hit by a ball hit back through the middle, and it took two games, but it made a great picture." Mark that one up to patience.

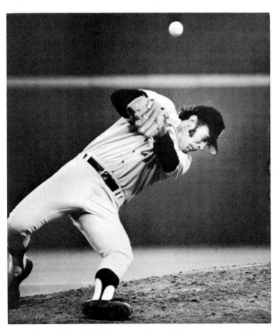
Ed Reinke concentrated on the pitcher for two games and came up with this reaction to a line drive up the middle.

Kennedy credits much of his success at sports photography to using extremely long telephoto lenses (400mm-800mm) to isolate his subjects. "I always try to use the longest lens possible," he says. "You have a good expression, and you throw the background out of focus, the subject really jumps out at you."

He says he was using long lenses before they became commonplace. "I was willing to take my chances. It was worth the risk to me of losing a few pictures along the way to use the longest lens possible. I've seen a lot of real good pictures ruined by being underlensed."

Reinke is a little more conservative in his choice of lenses, saying "I think it depends on the coverage. If I'm alone, I will tend to shoot loose enough to not crop something out of the frame that I want, and still blow it up to a good image."

Lens selection is also dictated at times by the event and the size of the crew you're working with. "At a Super Bowl or World Series, the tendency is to be as tight as possible because there is no question that the peak action is enhanced by tightness in the shooting," Reinke says.

"But, when you're alone, you can't afford the risks you can take when you have team coverage," he says. At the local level, for example, a basketball game where he has another photographer working with him, his approach is also different. "That makes me feel like I can use a 180mm at the basket, because I'm covered by the other person. If I'm the only one there, I generally won't take that chance."

Porter Binks believes that his choices have evolved. When Binks was just beginning to shoot sports, he thought "you had to shoot everything with a 300, then a 400, then a 600, and after making an untold number of mistakes, I learned there was nothing wrong with having a

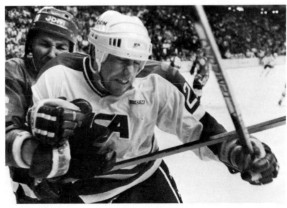

Keeping an extra camera with a wide angle lens around his neck paid off for photographer Mark Duncan with this hockey collision against the glass in the Winter Olympics in Calgary.

wide-angle lens hanging around your neck. It has helped me, that's for sure."

Every sports fan has a favorite picture.

One of the classics is Harry Cabluck's picture of Boston Red Sox batter Carlton Fisk trying to use body language to keep a home-run ball fair in the sixth game of the 1975 World Series against Cincinnati. Baseball historians call it one of the greatest baseball games ever played, and Cabluck's picture is the symbol of that game.

Cabluck's position was in centerfield, just over the fence with an 800mm lens. His primary assignment was to shoot every pitch, hoping to get the home runs and key hits from a different perspective.

Cabluck says the assignment called for concentration, some skill and a lot of luck. When shooting, Cabluck says he watched and followed the game, "just like being an outfielder. What am I going to do if the ball is hit to me?" Cabluck was constantly refining what he was going to do in any given situation.

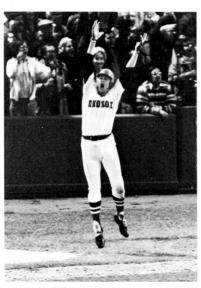

Harry Cabluck followed batter Carlton Fisk as he leaped for joy after homering to win the sixth game of the 1975 World Series.

When Fisk swung that bat and danced down that line, Cabluck moved with him, firing frames that tell the story of Fisk's struggle as he watched the ball arc toward foul territory. He then shot the jubilation as the ball stayed fair for the home run.

Despite moments when Fisk was obscured by other players, Cabluck concentrated and stayed with him because he knew that Fisk was the story of that game.

That kind of coverage can be extended to a Little League or high school baseball game. Instead of taking the safe position

along the first base line, try shooting from one of the foul poles, or from just over the centerfield fence. Even a play at second base looks different from those perspectives.

And if the action lags, follow Kennedy's example and look for the actions of a player to give you a picture. Got an infielder blowing bubbles? An outfielder doing stretching exercises during the game? A catcher with dirt all over him, or a group of bench warmers wearing their hats at odd angles? Any of these will make a picture when the action doesn't give you one.

The key to good coverage is to see a variety of pictures. Over the course of a season, follow Risberg's suggestion and try to shoot from several different perspectives, always looking for a different picture than you had from the game before.

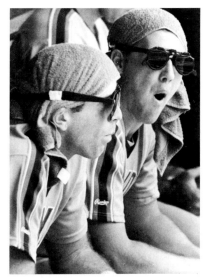

New York Mets players sporting towels on their heads made for a different picture from a dull game by photographer R. Jonathan Rehg.

Another way of expanding your sports coverage is to look for subjects that will make interesting photo essays.

Susan Ragan saw stories in the sports pages about a young jockey, Julie Krone, who was quickly making a name for herself. Ragan contacted the jockey's agent and proposed a story. The result was an interesting look at a sport that generally doesn't get much coverage.

But it wasn't as easy as Ragan's pictures made it look. Ragan found

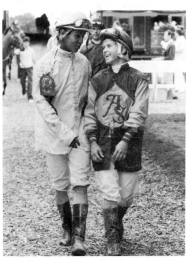

Susan Ragan found jockey Julie Krone, right, to be a tough subject while putting together a package of pictures on the young rider.

that Krone, despite her fame, was very self-conscious. "Her father is a photographer and she's very conscious of the camera," Ragan says. "It took much longer with her to break through that shell. There were days when I had nothing, but I kept going back and finally she mellowed out."

Good pictures can happen at any level of sports.

Amy Sancetta's picture of a high school basketball player agonizing over a loss in the state tourney while the winners celebrate is a solid storyteller.

"I was going for a good picture of the girl on the ground, and the others danced through the frame," Sancetta says. "I was lucky."

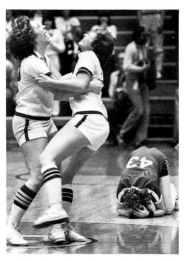

As the winners jump for joy, the loser falls to the floor in this picture of emotions at a girls high school basketball championship game by Amy Sancetta.

But that luck resulted from some planning. Sancetta had followed the story of the game, as well as the action. She knew that the player on the ground was not only the top scorer, but also had caused a turnover for her team late in the game. The other team had converted that turnover for the lead and the championship.

Sancetta knew "it was more important to get a good picture of the key player, than a good picture of just any player." That's why she went for the dejection, rather than move on to the jubilation. She moved into a position to make the picture and the jubilation element rounded out the picture. Although it is several years old, it is still one of her favorites.

At the other end of the basketball scale, Ragan caught U.S. Olympic men's team coach John Thompson glumly leaving the floor as the Soviet players celebrated their win

over the Americans in the 1988 games in Seoul.

Ragan said she was watching Thompson to see how he would react to the loss. As he moved across the floor, the elements of victory and defeat came together in the frame.

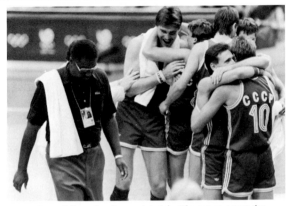

Susan Ragan followed a disconsolate John Thompson across the court and made this picture as the U.S. men's team coach passed the winning Soviet players during action in the Olympics in Seoul.

To make up for a lack of sports interest and training as a child, Ragan prepares for her assignments by doing as much research as possible. "I read a bunch of stuff because I wasn't raised to know it," she says.

Ragan is nervous as she nears game time, and tries to distance herself from the noise and clamor of the sports scene. "Mentally I try not to think of it too much because I worry too much. But as soon as the event starts, it goes away. My adrenalin kicks in and I start thinking through my eyes or something. There can be billions of people around, but I am into myself. When people talk, I don't hear them."

She says her attention becomes very focused. "My mind never wanders. I anticipate things without thinking about it. It's instinct, I think."

The idea of planning and preparation is a common thread.

"You have to think ahead," Cabluck says. "In football, for instance, you need to have a feeling for the quarterback, and know what he is thinking. If it's third down and eight yards, you know it's going to be a pass play. That's just doing your homework, knowing how the game is played."

Lennox McLendon says he tries to analyze the situation like a defensive back as the teams approach the line of scrimmage. What is the most likely play the offense will try?

When Franco Harris of the Pittsburgh Steelers scored a touchdown on the legendary catch known as the "immaculate reception," Cabluck was waiting in the end zone to make the picture as Harris came toward him.

The other team had just scored, and the Steelers were a touchdown behind and starting their drive a considerable distance from their goal line. "You have to think what is going to happen that is going to be significant," Cabluck says. "The only thing that would happen to change the game would be a Steeler crossing the goal line to score."

You just can't plan and study too much.

Before Cabluck moved into photo editing, he was a regular photographer at baseball playoffs and World Series. In the weeks leading up to the championship games, Cabluck would try to see as many television broadcasts of the teams as possible.

Like the opposing scouts, Cabluck would chart the tendencies of the teams' players so he could anticipate their actions when he covered them a few weeks later in post-season play.

Add Sancetta's vote to those saying you have to think like you're in the game, like you are the runner on first base. "Anticipate what they are going to do, just like the runner is, the pitcher is and the catcher is."

You learn in a lot of different ways, Binks says. "I shot minor league baseball for years, and I don't think I ever learned the game. But in the past six years, I've studied and learned from other photographers and from sitting next to Ernie, the ballboy at Baltimore's Memorial Stadium, telling you what is going on."

"I'm just now getting to where I think I understand it to react to plays," Binks says. "When you know the sport and especially when you have the chance to cover the same team for a long time, then you begin to use anticipation and reaction. When you can anticipate and react as fast as the player does, then you've got it," he says. "You're synching with them."

You're going to have a tough time of it, Reinke says, if you expect to make good pictures just by showing up at the stadium. He's also of the school that a knowledge of the game and the participants is critical.

Risberg says he takes advantage of all of the material available to stay informed about the sport he is covering at the time. "I always try to read the basic newspaper stories, but more than that, I read the handouts in the press box, the game notes and the statistics."

There is a lot there to help the photographer, Risberg says. "Many times I've gone to the ballpark and read the press releases and found a half-dozen ideas of things to watch for. You get some great tips just by reading the press handout sheets that many people throw away."

"What I try to do," Risberg says, "is come up with a combination of doing my homework, and mix that with instinct and experience. Sports photography is something where experience really counts."

Risberg uses a picture of Greg LeMond in a San Francisco bike race as an example. All the other photographers were at the top of the steep hill, but Risberg knew from following biking that "if there was going to be any

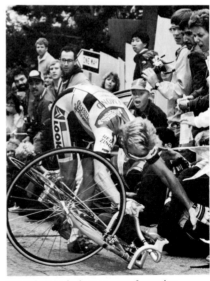

Eric Risberg picked a spot away from other photographers and made this shot of bike racer Greg LeMond tumbling during a race in San Francisco.

good expression it would be near the bottom where the rider tackles the hill. I positioned myself halfway, where the rider would shift gears. He had a problem, and I made a picture of him tumbling," Risberg says. "Knowing the sport and going where the other photographers aren't paid off. I've always tried to listen to my instincts. Sometimes it's better, but it's always different."

Reinke says, "you have to be acutely aware of what is happening in the game and what is happening around you. And you have to read the sports pages to know the people. You have to know what to expect next. That is why I just can't fathom someone making a good basketball picture, for instance, without knowing something about basketball."

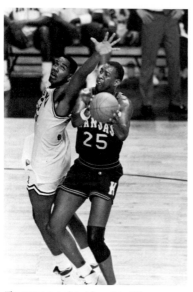

The action is isolated from this different perspective as Danny Manning of Kansas goes for a basket against the defensive efforts of Oklahoma's Stacey King in Susan Ragan's picture from the championship game of the 1988 NCAA Final Four.

Reinke cites the championship game of the NCAA Final Four in 1988 between Oklahoma and Kansas. He says you have to ask yourself questions as the game progresses. "Who is going to make that last basket, who is going to take the last shot? You knew it was going to be Danny Manning, a percentage shooter. You have to be aware of that. You have to be on him. That's nothing more than planning."

He adds that "you have to be ready to shift your coverage, but you are increasing your chances tenfold by knowing he's the logical choice."

Binks says he learned about covering football from watching former *Washington Post* photographer Dick Darcy work the sidelines at Redskins games. Darcy would move up and down, Binks says, using an old zoom lens that had

other photographers scratching their heads, but when they picked up the paper the next day, Darcy had the pictures.

"He knew his stadium, he knew his angles," he knew what to expect in any given situation, Binks says. "He taught me to shoot football down on my knee because that is how the players see it." Darcy taught Binks to learn about the stadium and what different angles would provide, then learn everything you could about the players so you could anticipate their actions.

Binks says, "If you're working at ballparks you know well, and you know your players, you've got half the battle won. The rest is up to your reaction and your knowledge of the game and your technical expertise."

Sancetta got a good picture at a tennis match because she knew the personalities of the participants. She was in a position to make a picture of tennis player John McEnroe kicking an intruding television camera because she knew that with McEnroe, "the

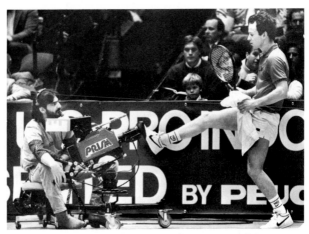

Tennis star John McEnroe takes aim at a television camera during a match in Philadelphia in this picture by Amy Sancetta.

good, different pictures are going to happen off the court because he is so volatile." So, when other photographers dropped their lenses during a break, Sancetta stayed on the temperamental star.

She agrees that studying what you cover is important. "I think what makes some people better at sports, is they know the sports they cover."

Before you get to that level, though, there are some basics.

BASEBALL

— If no one is on base and the batter is right-handed, try focusing on the third baseman or shortstop. They are most likely to handle any ground balls. A left-handed batter probably will hit it toward the first or second baseman.

— If a runner is on second or third, be prepared to cover home plate since any hit, or a long fly ball, will move the runner.

— If a runner is on first, with one out, be prepared to swing to second base to get the double play attempt. If the pitcher is at bat, watch for the bunt.

— Always make a few frames of the starting pitchers. They will figure in the game story, win or lose.

— If a slugger is at bat, drop your coverage of the rest of the game and concentrate on the batter. If he hits a homer, it's a good picture, and if he strikes out, it is significant and he may react to the lost chance.

— When a batter hits a home run, swing your coverage over to the pitcher to get reaction. Until the batter rounds second base, you can't see his face anyway. Move back to the batter as he passes third and gets congratulations from the third base coach, and the players at home plate.

FOOTBALL

— Cover the quarterback from behind the line of scrimmage to cut down on the number of players between you and your subject

— Use long lenses and work from farther down field to reduce the angle and open up your coverage zone. Ground plays will come at you and you'll be in a better position to cover pass plays, too.

— On fourth down in a kicking situation, move behind the line of scrimmage to cover the blocked kick or

kicker's jubilation.

— For a good jubilation picture, position yourself between the driving team's bench and their scrimmage line when they are in a scoring position. When a team scores, the players usually run back toward their bench celebrating.

— If it is a very cold day, go to the side of the field facing into the sun and try for a backlit picture of the players breathing. It is a nice feature.

BASKETBALL

— Move toward the sides of the court and shoot back in toward the basket with an 85mm-105mm lens to isolate the action and neutralize the background.

— Using a 180mm or 300mm lens, work the midcourt area. The lighting will be better because you aren't shooting up into a black backdrop. And, the pictures can be better because you'll get more eye level contact and fewer armpits and elbows in your photos.

— Watch the coaches for reaction to give your sports editor something to use as a sidebar. The story will always have coaches' comments.

— If the gym is badly lit, try shooting from some elevation. By shooting with the lights, instead of into them, your negatives will have much better exposure. Also, rim action from straight on gives a different perspective.

GOLF

— Study the course map and find combinations of holes you can cover easily to give you the most chances to catch the leaders in a variety of situations.

— For insurance, make a few frames of the top golfers teeing off early in the round.

— Don't line up exactly with the hole and golfer. Try for an off-line setup to avoid distracting the player.

— Watch your background. If possible, move to a position that provides a neutral backdrop, like a grove of trees. A bright sky as a background will make both calculating your exposure, and later printing in the darkroom, much more difficult.

While motor-driven cameras give today's photographers the benefit of having lots of frames to pick from, Cabluck believes that the best discipline comes from following the practices of the photographers in the Speed Graphic days.

That discipline, Cabluck says, caused you "to anticipate peak of action in sports, because in those days it was 4x5, one shot, and the shutters wouldn't always freeze the action. So you had to have the peak of action, because at the peak there is less motion."

"It's easier now to go out and machine gun from the hip," and have several frames to select from, but it takes "less discipline," says Cabluck, who concedes that he often uses a motor drive.

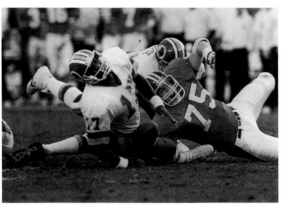

Washington Redskins quarterback Doug Williams grimaces in pain as he twists his leg during a Super Bowl matchup with Denver in this sports action picture by Rusty Kennedy.

Several top sports photographers say they try to make the first exposure of a sequence, the key frames, then they let the motor run off a few more frames for followup protection. These photographers say that they have found that hitting the motor early often leaves them with the key picture "between" frames.

And, when it comes to equipment, Risberg says that sometimes less is better. "One of the things that has worked well for me has been to travel light." He refrains

from "taking three or four cameras with every focal-length lens I have to a game." Instead, he works "primarily with two cameras - one with a long lens, one with an intermediate zoom."

Binks says he finds working with the new zooms is a big help because it cuts down on the amount of equipment he has to handle. "The advent of the fast zoom has brought the sports photographer up to speed with having a variety of lens in one." With the zoom, Binks says, he can cover "pregame headshots, a feature in the stands, or a play at homeplate."

"I use a zoom preset" at a focal length, Binks says. "I use it as though I had all of those lenses in my bag. When I get to messing with zooming it in and out, I'm dead." And, that's part of knowing your equipment and how it works best for you.

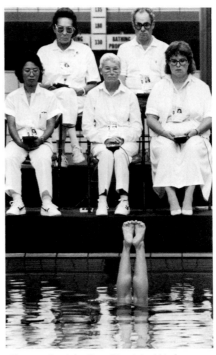

That simplistic approach pays off when you have to react quickly, Risberg says. "Too many times, I see people making it very difficult for themselves by trying to take everything. Keeping it simple has allowed me to have great mobility in situations where you have to move quickly to capture a breaking moment."

And, once you've got the picture, don't forget to give the editor enough caption information to work with.

Photographer John Gaps III switched his focus from the competitor to the focused attention of the judges in a synchronized swimming competition at the Summer Games in Seoul.

"In at least the first general edit of a deadline shoot," Binks says, "I rely on what the photographer has given me on the caption bag."

At a football game, Binks says, they might not realize it "but the photographer does the first edit by giving me a star on a key play, or a key interception, and gives me the down and the time and the quarter. That's one of the great failings of sports photographers in particular, and most photographers in general. They don't provide the kind of caption information that makes the editor's job easier."

Binks says "A good editor will find the good picture on the film, but then you have to tell the layout person what the picture means, why you picked it." You may tell the layout person it's a good picture, but that team may have lost.

The layout person is looking for the significant picture more times than not. Binks says "there is a real misunderstanding about that." The photographer should be asking "Do I have the moment here?" And, that's not only the moment the photographer thinks is right, "but also the moment the writer thinks is the turning point of the game, Binks says. "I find it is much easier to push the ones that tell the game story, they stand on their own."

But, the editor has to know it's the right selection. Binks says of sports: "You've got to be a reporter. When you are a reporter and a photographer, you capture the key moments and you mark those on the bags."

PORTRAITS:

Personality in a Photograph

It can be a straight headshot. Almost passport style in presentation.

Or a more complex picture such as an environmental portrait. A picture showing something about the person's life or work.

But the idea is the same - to capture a person's personality in a photograph. From the stark, super sharp quality of a Karsh portrait to the telling images of Arnold Newman, portraits bring the subject to the reader. It can depend on the intended use of the picture. A well-composed headshot works for a one-column, the environmental portrait is more suited to multiple-column display.

The trend over the past few years has been the environmental portrait. This is a picture that puts the subject in a setting that provides a quick identification of that person - a jockey in his silks with a horse, a scientist in a lab, an artist at his pallet.

David Breslauer says you can say a lot with "something as simple as a portrait. A lot of times you can convey much more in the photograph than the mere likeness of the person."

Not posed like they are doing something just for the photographer, but presented in a clean, straightforward manner.

That's a relatively new thing in newspaper photojournalism.

Ed Reinke says there's been a big change since he started out nearly 20 years ago. "That's changed dramatically for me. In the early '70s when I started at a newspaper, we didn't want to run pictures of people looking into the camera." He explains that "that's different now. I like to have them look at me right through the camera, to talk to me through the camera, to talk with their hands toward me."

Breslauer says you have an advantage if you know something about the subject because you can then use that to "convey something about the person by his photograph."

The right angle and a good eye for lighting highlight's the smoke from Red Auerbach's trademark cigar as the Boston Celtics executive watches a team practice in this portrait by photographer Elise Amendola.

He tries to vary his approach. "I try to make it different, intentionally. I'll use dramatic lighting, high contrast, light against the dark, dark against light, just to take a different look at something. If there is a way to show them in a different sort of way, I'll try it."

Eric Risberg likes to gain intimacy with his subjects. He has several ways he approaches an assignment with an individual. "I like to do my homework," he says. "I like to read the story, check other sources, ask people about the subject." He says that isn't always possible, though, and then he'll "try to go out and ask the subjects to talk about themselves. I'll ask questions, maybe not directly related to the story, but to get them to talk about themselves. People like to talk about themselves."

The San Francisco-based photographer says he has another plan for when he is assigned to shoot a controversial subject, who might not be comfortable being photographed. "In that situation to relax them, I try to get them to talk about a non-controversial subject."

"I spent a good part of an afternoon with Richard Nixon one time to make a picture of him," Risberg recalls. "I struck up a conversation about baseball. He loves it, and knows baseball more than most people. By talking about that, as opposed to Watergate, or politics, I had an excellent rapport to make good photographs."

It paid off later, too, Risberg says. "A long time after that, he remembered our conversation about baseball and it helped when I had to photograph him again on another assignment."

New York freelancer Wyatt Counts involves his subjects in making the picture better. "Rather than force a setup on a subject, I try to get them to give me as much input as possible," he says. Oftentimes, Counts says, it works best when you end up "assisting" the subject.

For a portrait of artist-author Laurent de Brunhoff, who continues the character Babar the elephant that was created by his father, Counts first thought of getting one of De Brunhoff's books, or a Babar poster, to use as a prop. But he was afraid that might be awkward.

Artist and author Laurent de Brunhoff drew his character, Babar the elephant, for photographer Wyatt Counts.

So, he brought a pen to the photo session and talked with the artist about drawing Babar. De Brunhoff quickly

sketched a likeness of Babar on his hand, using the thumb as the trunk.

Counts used one Vivitar 283 strobe, fired through an umbrella, to light De Brunhoff. He wanted to use direct, but softened, light to bring out the lines in the artist's face without a harsh feeling. He finished the lighting setup by adjusting the strobe to give him one more stop than the light coming through the blinds in the background. This helped to darken the background and let Counts use the blinds as a visual device.

Counts made a test exposure on Polaroid film and gave it to De Brunhoff, who really liked the photo. Counts had a relaxed subject, and soon had his picture, too.

Amy Sancetta's picture of a scientist studying the effect of light on sufferers of Seasonal Affective Disorder uses the basic rules of good portraiture.

Amy Sancetta's portrait of a scientist doing research on the effect of light on people's moods is a simple, straightforward picture. But, by using the light available to her, Sancetta made an eye-catching picture.

When she first arrived at the assignment, the scientist had already enlisted the aid of a volunteer to model his invention - a hat with a light built into the rim. Sancetta made a few frames of that setup, with the scientist "helping" the volunteer with the headgear. That would have been the picture to make several years ago. But, Sancetta wanted to more closely tie the scientist to the helmet without the awkward set-up look of the two-person pose.

To show the effect of the light built into the helmet's rim, Sancetta first had the scientist turn on the battery powered light, then turn off all of the other lights in the

room. The result was a well-exposed picture of the scientist's face, but the shape of the safari-type helmet was lost against the dark background.

Sancetta solved that problem by putting the scientist on a stool in an open doorway with all of the hall lights on behind him. The hall lights provided the separation needed to bring out the helmet without losing the effect of the light built into the brim of the hat.

Sancetta could also have provided that separation by lighting the background with a strobe set to put out at least a stop less light than the face was getting from the the fluorescent tube. If she had intended to use the picture as a color illustration, she could have also put a gel on the strobe to introduce a color to the background.

But, since the picture was intended primarily for black and white use, the hallway lights were a simple solution that worked well for her.

Doug Pizac used the background in a different way to make a portrait of a movie producer. To separate the producer's white hair from the light-colored building behind him, Pizac aligned the subject with a dark entranceway in open shade area where the picture was made. Then, he used a 180mm lens to pull the background closer, while throwing it out of focus.

"My style is to surround people with the things that distinguish them from other people."
— **Amy Sancetta**

The combination of location and lens selection made the subject stand out and provided visual impact.

The photograph of the scientist is typical of Sancetta's approach. She seeks to keep the picture as simple as possible, while giving the reader a look at what is special about the subject.

Sancetta says "my style is to surround people with the things that distinguish them from other people. When you go into someone's environment to shoot a portrait, there is something around the subject that makes them special.

Everyone has something that is a symbol of what they do."

To quickly establish a working relationship with the subject, Sancetta uses the same kind of approach Risberg uses. She simply asks them to explain what they do. She says that gets them talking and relaxed, while at the same time giving herself ideas for pictures.

But, Sancetta makes an important point when she tells of her last step before making the picture. "I trace my eye around the outside of the frame, slowly around the corner to see if it works, or if I've left unwanted dead space. If you do that, it will tell you if the picture is not balanced. I'm really conscious of what space is open and what space has something in it. For instance, if I have an open space on the left, I try to balance it with an open space on the right. You can balance empty space the same way you can balance busy space."

Famed aviator Jimmy Doolittle poses with a globe for this portrait by photographer Eric Risberg.

Risberg also tries for an approach that on the surface seems simple, but is actually complex in its planning and execution.

"With portraits," Risberg says, "I try to keep a simple background. Sometimes I bring a clean background to a subject. It can be a seamless backdrop, or a cloth background, or a painted canvas, or something like that. I will bring my own if it is a situation where that will work."

Risberg also limits the props in a picture to get the clean composition he wants. "I try to never have the subject handling more than one item. That keeps their attention focused, and makes for a cleaner picture."

His portrait of famed aviator Jimmy Doolittle shows this approach. For a picture to go with a story on Doolittle's 90th birthday, Risberg used a strobe baffled by a softbox, a black seamless backdrop, "and got him peering over a globe, looking at his route to Tokyo and where he flew on the bombing raid to Tokyo."

Risberg also likes to take a low-key approach in order to keep his subject's attention. "I try to work with a simple amount of equipment. I find when I have all sorts of equipment, all sorts of bags, all sorts of lights, people become intimidated." Risberg avoids that "by working with only one or two cameras, with one umbrella or softbox, just a simple lighting setup and not a lot of gear around, and being in control of the situation."

While Risberg avoids elaborate lighting setups if possible, that extra equipment isn't likely to bother Pizac's subjects. Based in Los Angeles, he frequently photographs entertainers, and they are used to seeing the technical equipment.

In fact, Pizac thinks that they appreciate the extra time he invests to make the picture as good as possible. "They realize that I am taking the time and energy to do a good job," he says. "They are appreciative and cooperative, especially the old time movie stars. They know what quality work is."

Counts agrees. "If you come in pushing a cart full of gear, and assure them it will be used quickly, I guess they are kind of flattered," he says. If they still look worried, Counts tells them "I may not use it all." That usually defuses any problems, he says.

Photographer Doug Pizac had entertainer Sammy Davis Jr. hold on to this stuffed bear to relax during a photo session in his home.

Pizac's picture of entertainer Sammy Davis Jr. with a stuffed bear is an example of the extra lighting power Pizac often works with. For the portrait of Davis at home, he lit the scene with three strobes.

The two lights to the front of Davis, one with a reflector and the other with a screen, were regulated to provide "fill light." Pizac arranged the strobes with the main light coming from the right rear. To keep the tonal range between the white toy and Davis from being too great to easily reproduce, special attention was paid to lighting.

Like Risberg, Pizac sometimes uses a prop. In this case, however, the stuffed bear served another purpose. It gave the subject something to hang on to, which is a trick to help him relax.

By positioning Davis to take advantage of the other element in the picture, the painting behind Davis, Pizac adds color to the scene while also filling the void in what could have been a plain wall behind the subject.

Another approach is making your subject dominant in the image.

For impact, Lennox McLendon tries to make his subject a bold image. He likes his subject to be at least 50 percent of the image.

Photographer Lennox McLendon likes to have his subjects take a dominant position in his pictures, like this portrait of automaker Lee Iacocca.

His picture of automaker Lee Iacocca, using his collection of cartoons

on the wall of his office as a backdrop, is simple in its execution, but typical of what McLendon tries to do. "I try to get some personality to come out in the picture," McLendon says, "I try to capture the essence of the person."

Another interesting portrait, simple in its approach, is David Longstreath's study of twin basketball players at the 1989 U.S. Olympic Festival.

Longstreath used one prop, a basketball, to introduce a simple identifier into the picture. He made the picture in a corner of a gym, under a ramp, where the long, disappearing wall would provide a clean background. And, he picked an area with open daylight coming through the windows.

Longstreath didn't have much chance to prepare for the assignment, but he knew "we would be looking more for an environmental situation instead of

A long lens and clean open shade were the right combination for David Longstreath's portrait of twin sisters on an Olympic Sports Festival basketball team.

them playing basketball. I looked around for some pure soft light and saw a ramp area where the light was right."

When Longstreath arrived, the team had just started practicing. Because he didn't want to wait until after the practice when they would be tired and sweaty, he asked the coach for two minutes with the girls. That turned into ten minutes because the twins were so animated. They made it easy for Longstreath. "I didn't have to set anything up," he says. "They put the picture together themselves" because of their natural relationship with each other.

Longstreath shot the portrait with a 300mm f2.8. "I just backed up until I got what what I was looking for. It

all came together. Good composition, soft clean light and a clean background."

Doug Pizac took actress Bess Armstrong to a nearby shaded area for this portrait, rather than forcing a situation in a crowded restaurant where she was being interviewed.

To get that clean light and background for a portrait of actress Bess Armstrong, Pizac moved the shoot from the restaurant where the interview was going to take place to a building a few doors down the street. By carefully positioning her to take advantage of the open shade, Pizac made a clean image that required no dodging or burning when he made the print.

Sometimes you don't have to go quite that far. Instead of shooting actress Dee Wallace-Stone in the lobby of a restaurant, Pizac moved her just outside the front door to a shady area under a tree.

Using a a reflector to kick in sunlight and a strobe behind her to accent her hair and separate her from the background, he made an effective portrait of her. In this case, the reflector was a commercial product made for photographers, but it can be something as simple as a large piece of white cardboard.

Sometimes you can't move the subject to make a better picture. If the subject can't move, then it's up to the photographer.

Sancetta suggests changing your perspective on some assignments to give the reader a different view.

That isn't difficult, she says. "You can lay on the ground, you can stand on a table." For a portrait of an organist, Sancetta checked with the subject, then took off her shoes and stood on top of the organ. "I looked down on him, there must have been 600 keys. It made a nice

picture, no dead space. He's surrounded by the keyboard."

"It's a good example of looking for a different angle for a portrait instead of being eye to eye with the subject," she says.

Photographer Amy Sancetta took a high vantage point to get this different view of a department store organ player.

Another option exists.

You can also change lenses to make a better picture. Pizac was faced with a cluttered restaurant exterior as the scene for his portrait of the Smothers Brothers. By backing up and changing to a 300mm lens, he was able to isolate the duo and make a cleaner picture.

The Smothers Brothers comedy team was photographed by Doug Pizac outside a Los Angeles restaurant using a 300mm lens to isolate the duo from the busy environment they were posing in.

For the most part, none of the pictures required anything fancy. Just a knowledge of how to make light and composition work to the photographer's advantage. And, to

give the reader something more interesting to look at.

While Sancetta's picture of the scientist is an interesting illustration, sometimes editors are just looking for a good one-column picture to go with a story.

The simple headshot takes some care, though, to make sure the picture is a good one and can be easily reproduced.

The first item is to find a neutral background, one that won't distract or isn't too dark. A busy background pulls the reader's eye away from the subject. A dark background makes it difficult to separate the subject from the backdrop.

Actress Beverly D'Angelo poses in this sassy portrait by Wyatt Counts.

If you're stuck with a busy background, try to bring the subject some distance away from it, and use a wider aperture on your lens to throw the background out of focus.

If you have no alternative to a dark background, use Pizac's method and try lighting the background with a strobe, or moving a nearby lamp into position to give a rim lit quality to the subject's head. Then fill the subject's face with a strobe set to put out slightly more light than your rear illumination. This will provide the separation you need for good reproduction in the newspaper.

Have the subject sit, if possible. And, have the subject move forward to the edge of the seat, so their shoulders don't sag. Or, have them face you with their arms crossed. That is a relaxing pose for many people.

Then, photograph them from a slight angle to get the most pleasing "look" to the picture.

That front light can be managed to minimize the "flash" look. Use a strobe bounced off a ceiling, and a reflector card or your fingers to "kick" light into the subject's eyes and the shadows of his face.

Watch the strobe, however, to make sure you're not getting any flare off of something in the background. If you aren't familiar with the techniques of bouncing the strobe light or using a reflector, they are explained in the chapter on lighting.

The best lens for simple portraits is in the 85mm-105mm range. This gives a workable image size on 35mm film without the photographer having to be on top of the subject. It also lets you throw the background out of focus by using the wider apertures.

Photographer David Zalubowski captured himself in this portrait of a security expert who has equipped mannequins with video surveillance equipment

No matter what kind of a portrait you want, you should first master the basics of the simple headshot.

Then, by adding elements, you can make that headshot more sophisticated.

Even Sancetta's picture of the scientist uses the basic rules of the simple headshot to achieve a high level of quality.

Counts says that is important. "My basic thought is to start with the simple picture, then start adding elements," he says. Counts starts tight, then pulls back slowly watching as the elements are added.

You add an element to give the reader some identification with the subject. You haven't really taken away from the simplicity of the basic headshot, only improved on it. You put the subject into a setting that will provide greater identification for the reader. Now you have have elevated the simple headshot to an environmental portrait.

But, if you look closely, the simple headshot is still in there. A clean view of the subject, conceived like a one-column, but deserving of more space. The photographer has made a versatile picture that fills any need.

LIGHTING:
Using Light To Your Advantage

Lighting for photojournalism can be as complex as a multiple-strobe operation, or as simple as exposing your film properly on a sunny day.

But, the secret seems to be to use light, whatever the source, and make it work for you. Rusty Kennedy tells of the guidance he got from a veteran photographer at the former Philadelphia *Bulletin* when just starting out. The veteran told Kennedy, "Don't just look at your light meter, look at your light. Look at it, look at how it falls."

Kennedy says that "because meters are so accurate now, sometimes photographers don't look at the light," and they lose a lot of feeling in their pictures when they don't let light work for them.

A different twist on using available light, normally the light that is naturally in the scene, is to look at it as "all the light I need, I have" That can range from small flash units, to larger multiple head strobe arrays, to photo flood kits.

Kurt Mutschler says its a matter of deciding what you need to do to tell the story in the best way. At Mutschler's paper, he says, "We want the photographer to shoot pictures for content, not just for good lighting."

It doesn't have to be anything complex to be helpful. Eric Risberg explains, "a few years ago I had a chance to work with Mark Kauffman, the former Life photographer. I worked with him for two months and he taught me about

lighting, from simple assignments to how to light a building."

Risberg says the most important thing Kauffman taught him was, "you don't need a lot of lighting equipment to make good pictures."

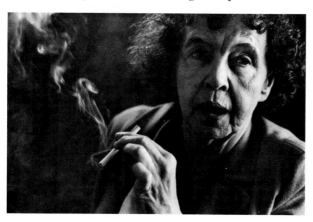

In fact, Mutschler says, the photographer should make a measured decision on whether to use flash at all. "Good photographers know when to use strobes and when not to."

Rusty Kennedy let strong available sidelight bring out the texture in artist Carolyn Wyeth and a slow shutter speed gave the cigarette smoke a wispy feel in this portrait.

Mutschler says in some situations, using a higher speed film and no strobe will enable the photographer to bring back the best image in terms of quality and content. Other times, lighting and slower speed films are the answer. The photographer has to learn the difference..

"Some photographers will use strobe where it hampers their ability to make the best picture," he says. As an example, Mutschler says a photographer covered a meeting in a big auditorium. The emotion of the people involved in the session was the key element. If the photographer used a strobe, the whole background would go dark and the context would be lost. In that case, he says, "it was better to use higher speed film and get a better image, a more realistic view, and the photographer was able to shoot without being noticed."

Understanding that equipment will help you stretch its usefulness. "Being a photojournalist," Mary Ann Carter says, "you have to be adaptable and know what your

tools are going to do. A strobe, an umbrella, a softbox, or the ability to push film, are just that, tools to be used when they are needed."

"You have to look at the light that is there," Carter says, "and figure out what is going to work in that situation. What worked today, won't always work tomorrow. What worked on chromes, might not work in black and white photography."

Carter says, "The best thing to do is to practice with your tools, one foot from the subject, five feet from the subject. Learn what the light does, what it doesn't do."

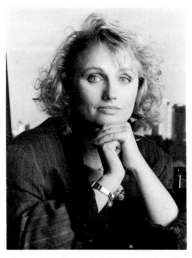

Actress Tess Harper is lit by one strobe, off camera, in this portrait by Wyatt Counts on the balcony of a New York hotel room. The lighting balances the exposure on the actress with the sunlight hitting the buildings in the background.

Doug Pizac says those practice sessions can reveal a lot. Approach them with several objectives in mind so you can get the most information about your equipment.

For instance, check the fall off of light from your strobe equipment so you'll know how it will light scenes with various lens. Pizac says, for example, "The Vivitar 283 covers a 35mm lens uniformly," but cautions that using a 24mm lens with the strobe will produce falloff, the edges will get less light than the central area.

Adapters are available to spread the light, but Pizac says there are some instances where the fall off helps. If you're working in a crowded hallway, for instance, like a news assignment outside a courtroom where people are on either side of the subject, but closer to the photographer, Pizac says, "use a 24mm lens with no attachment on the strobe. The subject will be properly illuminated," and the "light fall off from the strobe will be enough to correctly expose the people on

"The best thing to do is to practice with your tools..."
— MARY ANN CARTER

the fringe, since they are closer to the light source."

If you're going to be doing a great deal of lighting, Carter suggests a couple of items that will help you gain the best quality from your lighting equipment.

She finds that the Minolta flash meter, which measures both strobe and ambient light, to be extremely helpful when setting up lighting units that don't have automatic exposure controls.

Another tool she uses is a Konica instant press camera. It uses Polaroid film so you have "instant" feedback on your lighting.

Carter says, "I find it helpful because it tells me when I have a reflection that I don't want, or a if I'm throwing a shadow that is awkward. It's not for determining exposure, that's what I use the flash meter for, but it's for looking at relationships in the picture."

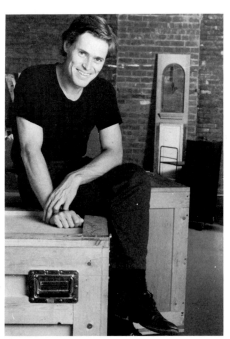

Wyatt Counts' portrait of actor Willem Dafoe uses a single umbrella to soften the strobe's effect.

"It gives you a sneak preview of what is going to be on the film. If there is a glaring error, it will show you where it is," she says.

Wyatt Counts also uses the Polaroid method to check his lighting. With the Polaroid, he says, "You get some idea of what your light is doing before you commit it to film."

He also uses the Polaroids to smooth over any fears his subjects might have. If a subject seems nervous, Counts will make a quick exposure on the Polaroid film and give it to them "so they can see you're serious

about it and making them look good." That usually relaxes them.

Counts also uses a Hawk remote system. It's a radio device to fire his strobes. It frees him from having wires running all over the place, "where people can trip over them," he says.

Just as you have to pay attention to your lighting, you have to pay attention to your equipment, too. Pizac says not to forget to check the calibration of your various meters, both in the camera and the hand-held flash meter. He suggests shooting tests, carefully recording the data, then evaluating the film to see where there might be discrepancies. Also, check for situations that might fool the meter, or the photographer.

"A meter is only a guide," Pizac warns, "a starting point. Look at what the meter says and interpret the reading. Do not rely on it."

It's important to learn what lighting can do for you.

The simplest lighting exercise, which calls for the least amount of equipment, is flash fill. That involves using a strobe to fill shadow areas in a sun-lit scene.

A rule of thumb for flash fill is to set your automatic strobe, or calculate your strobe to subject distance on a manual unit, to produce one stop less light than the existing light exposure.

For instance, if the existing light is f11, the fill flash should produce light at f8. This way, the "fill" light will open up the shadows while the "natural" light will still be dominate and the scene will retain its natural appearance.

You'll need a camera that synchs at a 250th of a second, or faster, to make easy use of the flash fill technique. It's difficult without shifting to extremely slow speed films to use flash fill outdoors with a camera that synchs at a 60th of a second or slower.

Flash fill will give you an immediate quality boost

and make your negatives more easily printable without having to do extensive dodging in the underexposed eye sockets, or extensive burning on overexposed areas while fighting to retain detail in the shadows.

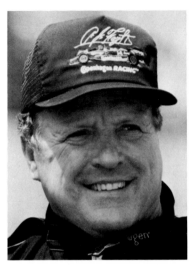

Using a slower speed film, like an ASA100 or ASA200 stock, will let you open up the aperture and cut down on the depth of field.

Carter explains how fill flash helps when shooting in the open pit area at the Indianapolis Motor Speedway. "At the track, I'm trying to get some light up under the baseball caps that everyone wears, and I want the background to come up normal, so I make the flash a stop less than the overall exposure."

Dave Parker used a 400mm lens and fill flash to make this headshot of Indy racer A.J. Foyt. The flash evened the exposure, knocking out the harsh shadows caused by the cap.

She says, "Its a matter of balancing out the light. If I'm exposing for the ambient light at a 250th at f8, I'll shoot the flash at f5.6. And, I can shoot the flash on camera because the sun wipes out the negative aspects of doing that."

Carter also uses flash fill in other situations.

For a magazine client, she needed a portrait of the co-speakers of the Indiana House of Representatives with the Capitol dome behind them. The only time they could do it was in the late afternoon, and the only place to shoot the picture from was a parking garage roof that would leave the subjects extremely back lit.

"In order to make the picture work, I had to light them," Carter explains. "And, to make the subjects stand out, I didn't want the background to be overexposed. I had to put a lot of light on the fronts of the subjects so

that the background would be a normal exposure, or a little underexposed."

Carter says, "It had a nice effect because the sun gave a rim light to the subjects and my light gave their faces detail and made the exposure work." Carter was shooting chromes, so the exposure was tougher. She knew she couldn't burn and dodge the image like she could with a print, so "I had to do my burning of the background in the camera by using the lighting and exposure."

Pizac even used fill flash to improve the quality of a picture he made of a peregrine falcon on a 26th floor window ledge. The picture was made to go with a story on the "urbanization" of the bird.

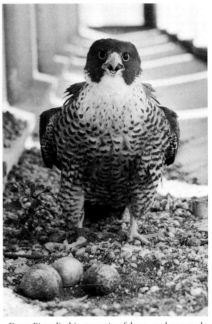

Doug Pizac lit this peregrine falcon, and exposed his film, with the same care he would exercise for any other portrait and the result was an easy to print photograph.

To separate the falcon from the harsh, cross lit background, Pizac used an extremely wide aperture to cut down on the depth of field. Then, he set his strobe, using the unit's variable power option, to fire at extremely low power. The strobe filled in the shadows under the bird's body and put some "catch" lights in its eyes.

It's not your everyday assignment, but a good example of how watching the lighting and using flash fill can raise the level of quality in your work.

The other basic lighting concept to learn is the use of "bounce" lighting to soften the effect of the strobe.

It gets its name from exactly what it is, a method where you "bounce" the strobe's output off a surface, usually a ceiling, to spread the light and cut the harsh shadows produced by the strobe. Bouncing the strobe light gives your pictures a more natural look, while still giving you the quality of a strobe-lit picture.

To bounce the strobe light, point the flash tube at the object (the ceiling in most cases) you'll use as a reflector, being careful to point the strobe's exposure sensor at the subject if you're using an automatic unit.

Hold the strobe so three, or four, of your fingers act as a small reflector to "kick" some of the strobe's output directly at your subject. Or, you can use a caption card or small piece of white cardboard, attached with tape or a rubber band to the strobe, to do this same thing. This will give you the brighter fill you'll want to lighten the eye sockets on your subject and provide a highlight, without hitting the subject with the full effect of the strobe light.

Bouncing the strobe light will take some practice, but is a pleasing lighting effect. Your pictures won't look lit, but will have a more pleasing tonal range without deep shadows.

One warning if you're using color film: Watch the color of the surface you're bouncing your light off of. The strobe will pick up that color and your subject will be "lit" with the colored light. Try to bounce off of neutral surfaces for this reason.

Getting back to basics is the message of two photographers, Pizac and Harry Cabluck.

Old photography and lighting manuals are a good source of information. Pizac says one of his favorites is titled, "1001 Ways To Improve Your Photographs." The 1945 book, Pizac says, "is a treasure chest of information. The photos themselves may appear dated, but the techniques themselves are everlasting."

He says grab one if you ever see it. He gets to look

at one that's in his uncle's collection of photo books.

Pizac does have a collection of old texts from the '40s and '50s, case studies on lighting from the Paramount and MGM studios, and he says those provide good examples to follow. "Go for those books and get back to the basics," Pizac says, adding that older town libraries often have these books on the shelves. "You've just got to search them out."

Mark Duncan adds another source for lighting ideas. "I get a lot of my ideas from looking at non-journalistic types of pictures to see how they use light, like corporate reports and industrial pictures."

Pizac says an important reason for being careful in lighting is that it will make other parts of your job quicker and easier. "People go out and do a job, and then they spend an hour printing." If they had shown more care when shooting, the printing would have been completed in far less time.

"When you make your picture," Pizac says, "you should correct the lighting so when you come in, you don't have to fool around in the darkroom." By working with your lighting at the assignment, "it's a straight print, and that's it." Pizac figures it's easier to spend a few minutes at the scene adjusting the lighting, than spend an hour burning and dodging on several different prints in the darkroom. "Darkroom work is a breeze," he says.

Cabluck learned his basics at the Fort Worth *Star-Telegram* in the days when film speeds were so slow you had to supplement any lighting. Cabluck looked to a two-strobe setup to put depth in his pictures. "Your subject in the foreground lit with one light, something in the background lit by another light, with the subject set off by the spill from the back light. We called it a 3D shot."

Some of the secret lies in the equipment, Cabluck says. "The secret to the 3D shot is to have the best light stands you can get. If you think you need a six foot light

This trio of headshots, by Mary Ann Carter, shows some simple rules to follow to achieve high quality. The hairlight on the subjects at left and center provide separation. But, the subject at right would show a reflection if the hairlight was used, so it was cut off for his sitting. And, the lens aperture was opened a half-stop for the center subject to give uniform densities to the negatives.

stand, get a twelve-footer. Get a light stand twice the length that you think you will need," so you have the greatest flexibility in placing your lights.

"And, put the camera on a tripod, even if you don't think you need to. Most news photographers probably don't use a tripod enough," Cabluck says. Using a tripod not only makes for a steadier image when shooting at slower shutter speeds (which lets the photographer take advantage of natural light), it also gives the photographer a platform to view his scene from. The photographer then has a better chance to look through the camera and make sure the picture is composed the way he wants it.

Cabluck's simple lighting formula is to "have the lights greater than 90 degrees apart." Visualize the scene like the "subject is in the center of an imaginary circle," he says. "You don't want to have the camera centered right between the lights. One light should be aimed at the subject and one on the background with some spill over on to the subject."

Cabluck adds an important item to watch for. "The mistake most people make is to put the subject light too high. It needs to be at less than 45 degrees so the nose doesn't split the lip."

An easy exposure ratio is used. "If the subject is f8, the background light would be a half a stop hotter so it

would show up."

Cabluck calls the old 3D setup "a simple two-light setup that looks like three lights." Simple, but still effective for many jobs. And, by using umbrellas to soften the lighting, the setup can have a more modern look.

As part of the basics, Carter suggests starting your lighting setups from the background and moving forward. "Solve your background," she says, "then light your foreground, the subject. And keep it simple and clean."

Pizac seconds that suggestion. "Watch your background. Keep it clean, or let it work for you by enhancing the subject," he says.

"If I'm in a factory and I have this large expanse," Carter says, "I have to figure whether I'm going to let it go black, or if I want some detail, or do I want it overexposed, or do I want it the correct color?" She says she runs through her options, asking, "What do I want it to do?"

When she knows the effect she wants, and she has lit it for that effect, she can go to her subject knowing that the background is going to work with the foreground to make a good picture.

At an assignment at the local phone company, Carter was faced with making a picture among rows of metal racks with electronic equipment "It took a long time to solve the lighting problem," she says. "I didn't have enough light to light a whole row, and I had to make a dull picture better by using dramatic lighting, so I ended up turning the background light toward the subject." She explains that "this put some rim light on him, and parts of the background were overexposed and other parts had a dimension to them because of the backlighting."

"Then," Carter says, "I lit him from the front with an umbrella. Finally, I composed it so I didn't have to go into the dark area that I couldn't light." A simple two-light solution to a tough problem.

Two portrait assignments show how Pizac handles potential background problems. In both cases, pictures of

actors Dom DeLuise and Jack Wagner, Pizac faced dark walls as the backdrop for his pictures.

He solved both problems the same way, positioning a strobe behind the subject each time, pointing at the wall. The natural fall off of the strobe's light "feathered" the density, giving a graduated light-to-dark look to the backdrop.

Doug Pizac's portraits of actors Dom DeLuise, left, and Jack Wagner were aided by bouncing a strobe light off the background to give separation between the subject and a dark wall which was a backdrop in each case.

There are other techniques and other tools.

Risberg prefers to use a softbox on his strobe to give himself the look of window light he wants for many of his pictures. He explains, "The softbox recreates window light, and it produces some of the most pleasing and natural light possible from an artificial source."

Risberg also believes that using a strobe and the softbox close to the subject brings a certain look to his pictures. "I try to keep the light, the main light, as close to the subject as I can. The closer the light is to the subject, the softer it gets." Risberg warns that "a lot of photographers make the mistake of keeping their light too great a distance from their subject, but in reality the closer you get it, the softer it is when diffused by an umbrella or softbox."

David Breslauer uses an umbrella or a softbox, but especially likes the effect of the softbox. "I like working with a softbox, it's a portable north window." He says it's easy to use. "There's no reason why a photographer can't carry one around. They're portable, they take up the same room as an umbrella."

Carter says you should get a feel for how the softbox or umbrella will fit in to your type of assignments. "A softbox falls off faster than an umbrella," she says, "so if you're lighting a subject and you don't want to light the background, use a softbox. But, if you want to light the background, use an umbrella because it is going to throw the light farther."

Counts believes that you can go for very different effects by using your lighting tools differently.

To strengthen a moody or sad moment in a portrait, he'll use a strobe direct on the subject and snoot it so the background goes dark. And, he'll have the subject look off camera.

For a softer effect to reinforce a more pleasant moment in a portrait, Counts will use a strobe with a softbox or umbrella. And, he'll have the subject look directly into the camera.

When shooting a portrait, Pizac sometimes uses a 4-foot by 4-foot screen which he places between the subject and the strobe. The screen softens the light and spreads it.

For simple portraits in an office, Duncan likes to supplement the lighting in a low-key manner. Duncan says, "I tend to light all of them, put small strobes inside the lamp shades to make it look like the natural light in the room." Using a small strobe to augment lighting gives Duncan the feel of available light and the quality of a studio shoot.

A large white reflector card was used by photographer Doug Pizac to fill the shadows in this picture of actress Dee Ann Wallace. The picture was made in the open shade under a tree outside a restaurant where she was being interviewed.

"If it is something that demands a more dramatic effect, I will do that, but I generally like the natural

approach. You light it so the subject stands out with a softer approach." With the flash in the lamp trick, "it looks like the regular lamp but with more power."

It's a balance of lighting and film speed. "If I'm going to shoot only strobe, I'll try to shoot only slower film, but if I'm balancing available light, I'll stick with 400 speed films."

> *"If I'm going to shoot only strobe, I'll try to shoot only slower film, but if I'm balancing available light, I'll stick with 400 speed films."*
>
> **— MARK DUNCAN**

For example, if the available light in the room is a 30th of a second at f5.6, but there are troublesome shadows, Duncan will light the shadow areas with strobes at that f5.6 exposure, then shoot the picture at a 30th. This way the natural balance of the room is preserved, but the quality and separation of the components is enhanced.

Breslauer explains it this way. "A lot of times, I'll try to use my lights to fill in the available light and clean up the balance. You see what your basic exposure is, and you light the scene to fill in the available light. Your exposure should include a mixture of the strobe exposure, which is regulated by your lens aperture, and your ambient light, which is regulated by your shutter speed."

He warns that this means you are often shooting your portraits at a 30th of a second or slower, so a tripod is important.

Amy Sancetta also likes to have a natural look in many of her assignments.

Depending on the situation, she'll, "try to use natural light as a second light, perhaps lighting the background, along with a strobe."

"If I have a choice, and I can put someone in a chair near a window, I'll use it as the main source, and fill in the shadow with a strobe. I'll light the person with some balanced strobe light on their face from the shadow side to give detail, but not overpower the window light."

Sancetta feels "natural light is so pretty. If you can use it in conjunction with flash, it can give your pictures a softer look."

Like Sancetta and Duncan, Ed Reinke likes to use existing light when he can. "As much as possible," he says, "I try to work with existing light. I think it (working with or simply augmenting existing light) is more challenging than going into a studio and completely controlling the light."

"If I'm going into a CEO's office," Reinke says, "my tendency is to make that portrait by just augmenting the light that is there." And he does that by using many of the same methods that Duncan, Breslauer and Sancetta use.

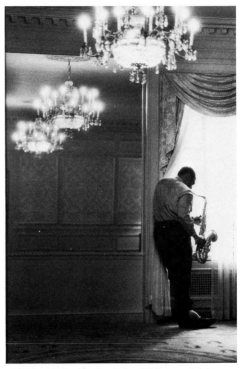

Taking a step back, using the available room lighting, and including the ornate atmosphere of a posh New York hotel room gives Wyatt Counts' photograph of sax player Clarence Clemens a feeling of quiet solitude.

There are specific instances where Reinke will also use light to help tell the story. He explains, "I made a portrait of a man making a low-budget horror movie, and I controlled the environment much more tightly, and used really low level light to make him look evil, which fit in with the story."

Reinke says you need to control the light to make it work for you. "It's up to us to marry the portrait with the story," he says. "I'll shut a light off completely, or move a light, if I can make a better picture that way." He adds that he makes these changes, "just in a feature, not in news situations. Never in news. So much that we do now is feature-oriented, we can reasonably take more control."

Carter says turning out the room lights, and using a strobe, is the easiest way to make a good picture of someone working at a computer terminal. "The strobe has to be where it won't hit the screen, high and off to the side, facing toward the subject."

Her method involves turning off the ambient light in the room and taking a light reading, using the camera's built-in meter, off of the screen. If the screen exposure is 1/8 of a second at f8, for instance, Carter will put the camera on a tripod, set the strobe at f8, and make her exposures. The exposure of the subject and the screen will be balanced.

You can also use a strobe to freeze action, or to add an effect to a picture with movement. Carter had a magazine assignment about an exhibit at a children's museum, the science of sport. The item they wanted to feature was an angular momentum device, which involves the child, "twirling around and throwing out their arm to see if it slows them down or makes them go faster," Carter recalls.

Carter had a young volunteer working with her. "He was twirling around and I was trying different things," she says, "and lots of different shutter speeds. I was trying to see if I could get the idea of this movement and still see that it was a kid."

You can also use a strobe to freeze action, or to add an effect to a picture with movement.

Carter tried so many different things, and so many shutter speeds, that her first volunteer got a little queasy and had to be replaced. After finding another volunteer, she continued the assignment.

When Carter felt she had arrived at the right shutter speed, she says, "I lit it, because the flash would stop his movement so we could see clearly that it was a child on the apparatus. The strobe light was directly above him coming down," she explained, and the picture combined the blur of the movement with the sharp image from the flash exposure.

To clean up the background, which was mainly other displays, Carter got up on a high ladder and used the museum's black floor as a plain backdrop. "There was even a red stripe for an accent," she says.

If you are shooting color film and using strobes to supplement existing light, inside or outside, you are often faced with a mixture of color temperatures.

A light source's color temperature is a scientific measurement, measured in Kelvin, of the exact color of light produced by the source. For example, a strobe produces a daylight balance of 5500° Kelvin. A common household or office fluorescent might be 4500° Kelvin, while an incandescent bulb might be measured at 3200° Kelvin.

Obviously, if you are shooting a picture in a room that has incandescent light and you add strobe lighting, the color balance will be off. The incandescent lit areas will be warm - reddish - and the strobe lit areas will be cold - bluish.

When you make a print or the engraver goes to make the separations from the chrome, only one of these shifts can be corrected.

The same problem exists when shooting in a room lit by fluorescent tubes. The fluorescent lit areas will be green and the strobe lit areas will have a daylight balance.

To make everything the same temperature, you can gel your strobes so they match the available light. This way the darkroom technician making the print or the engraver making the separation from the chrome only needs to make one correction.

A popular brand is the Rosco gel. It's sold in sheets at many theatrical lighting shops and large camera stores.

The Rosco 3304, a green gel, corrects the strobe to match the fluorescent lighting. "When I'm in a situation with fluorescent lights in the background," Carter says, "I

To make everything the same temperature, you can gel your strobes so they match the available light.

put those gels over the flash heads, and then put a 30 magenta filter on the lens. The gel makes all of the light fluorescent, everything will be green," she says, "then the magenta filter cleans up everything. The skin tones are true and the fluorescent lights in the background are white."

You need that magenta filter when you shoot chromes, but if you are using color negative film, you can go without it and correct the balance when you make the print.

If you want to filter the lights, not the strobes, the Rosco 3308 gel converts fluorescent to daylight.

You can also balance your strobe with incandescent lights. For example, the Rosco 3401 will balance with the portable lights used by television news crews. By putting a gel on your strobe, you can shoot fill flash in situations where television photographers have set up lights, or in a news situation where you are working among TV crews and can't control their lighting. This gel would also work in an office or home lit by regular table lamps or ceiling spots.

"The Rosco Jungle Book, a sampler of all of the corrective filters they make, is a good reference to carry in your camera bag because it tells you what each filter will do," Carter says, and will help you solve lighting balance problems. As a bonus, she says, the sample pages will cover the head of a Vivitar 283, so you can use them right out of the book.

You can also use gels with strobes to add a dramatic effect to a picture.

Carter has used a gel to produce golden sunlight on an overcast day. She had to photograph a subject in a corn field. The sun wasn't shining, and the client needed a late afternoon feeling. "I put an orange filter over the strobe in a softbox," Carter says, "and put the light to the side. It made it look like a late afternoon sun."

Others also use this technique. "I will use color gels to make a more dramatic sort of photograph when I'm not making a straight portrait of someone," says Duncan.

On one assignment involving a NASA plasma experiment, Duncan used a light red gel on a strobe to give

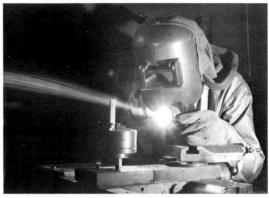

Mark Duncan's photograph of a NASA experiment in a darkened room by making a long exposure and popping in a strobe to provide detail.

definition to the subject to "juice it up a little bit. The assignment was done in a darkened room, with a long exposure. That showed up the plasma, and a small strobe then exposed the worker."

Another of Duncan's assignments was a portrait of a laser surgeon. He set up a strobe to light the subject from the side with a soft light. "The strobe had a gel to give a blue highlight to outline his face and body and he is pointing the laser at the camera."

Duncan shot the scene with a small aperture and slow shutter speed. The laser's guide light (a small aiming beam) is made into a starburst by the aperture of the lens. "It gave a feeling of the power of the device, since you can't actually see the laser."

Mark Duncan used a slow shutter speed and small aperture to make a starburst pattern with the guide light for a laser surgery device.

Like Reinke, Duncan warns that lighting tricks such as color gels should be saved "for feature material while sticking to straight documentation for news and sports."

Mark Lennihan used a strong sidelight to provide definition for the world's thinnest watch, with the owner of the company that produces the timepiece.

Careful handling of lighting, the available light that's there, or some supplementary light you've provided, can improve your photography. "I think lighting is one of the key factors in photography," says Lennox McLendon. "It can make or break a picture." He adds, "After the subject matter, lighting is the most important element."

Carter warns, though, that there is "no one right way to light everything. But, I guess that is true of photography, there is no one right way to shoot everything."

Pizac adds, "Make sure your subject is the subject, not the lighting. Enhance the photograph with proper lighting, don't dominate it."

Lighting is worth the occasional pain and headaches. It can make the difference, McLendon feels. "I think a photographer who really looks at his lighting will be far superior to one who doesn't."

ELECTRONIC PHOTOGRAPHY:

Pictures Without Film

Electronic photography. Digital images. Pictures without film.

The future of photojournalism is a camera without film. It will capture digital images on a small disk and send those pictures from the scene of a news event into a newspaper's electronic picture desk via a cellular phone or radio hookup.

"I think that the computerizing of photography is the beginning of the evolution of a new art form," says George Wedding, director of photography at the *Sacramento Bee* and a student of electronic picture handling.

Years away? Not really.

"The fact is, within the 1990s, we are going to be shooting pictures on electronic cameras everyday," says Porter Binks, a photographer and photo editor at *USA Today*, where electronic cameras are being used on an experimental basis now.

Nikon, Canon and Sony already are in the marketplace with electronic cameras. They look just like a conventional film camera, but you put a miniature data storage disk in the back instead of a roll of film.

The disks are small enough - about the size of an old 2 1/4 inch square negative - that you can carry several of them in your pocket. Current models allow 25 high-quality pictures, and 50 lesser-quality images, to a disk. And, the disk is reusable!

Binks already has used one of the cameras on an assignment. ""I covered an entire All Star baseball game without touching a roll of film," he says.

Conventional camera lenses can be used on some of the models with the focal length increased by a factor of four. A 200mm f2 lens becomes an 800mm f2 lens. So a photographer's pool of lenses isn't lost. It in fact becomes more versatile and valuable.

To view and send the images, photographers will carry a battery-powered unit about the size of a small knapsack which has a built-in television monitor and a transmitter.

No darkroom. No film. No prints.

Currently, the quality from the electronic camera does not match conventional systems..

At the inauguration of President George Bush in 1989, AP photographer Ron Edmonds - using a Nikon electronic camera - was able to make a picture of the swearing-in ceremonies, then transmit that picture to the world directly from the open camera platform. The picture was on its way to newspapers less than two minutes after Bush raised his hand to take the oath.

Conventional film coverage lagged behind another 25 minutes, making the difference for afternoon newspapers on deadline across the United States.

Currently, however, the quality from the electronic camera does not match conventional systems, and that is the drawback to more widespread usage. While the quality is acceptable if the image is transmitted and used nearly full frame, any amount of cropping or great degree of enlargement begins to deteriorate the image.

Each electronic image is made up of thousands of picture elements (pixels). These are the tiny tiles, set down row by row, that make up the mosaic image of a digital picture.

You'll remember that mosaic quality from the Mars space pictures in the early '70s. Each picture looked like it was made up of thousands of individual pieces. You could actually see the pixels.

Today's digital images are made the same way, only there are considerably more tiles so the pictures look less coarse. Typical pictures from electronic cameras now have 600,000 pixels, or bits of information, in each photo. These are positioned side by side, line by line, and when viewed from a distance appear to make a continuous tone picture.

To compare, a conventional 8x10 print from a full-frame Kodak Tri-X negative has the equivalent of millions of pixels. When electronic pictures reach a density of one million pixels, there is no discernible difference between the digital images and standard film images.

If the picture is handled electronically from beginning to end, experts believe the threshold for newspaper reproduction is actually lower than one million pixels.

An interim step to electronic pictures is the film scanner. Used in the newspaper's photo department or on remote assignments, the scanner digitizes the information from the conventional film without the need for a print.

This moves conventional photography into the digital world in an easy step and is a quick gateway to further electronic picture handling.

It can be used any place electricity and a phone is available. Photographers on the road can process their film in the bathroom of a hotel room, or at a one-hour photo shop, and send their pictures back to their newspaper without having to set up a darkroom to make prints.

The negative scanner, no bigger than a suitcase, allows the photographer to scan the image, crop it, adjust the tonal range and color content, and then transmit that picture to the photographer's newspaper with a caption.

Or, used in-house, a newspaper can input digital information directly from the photographer's film to its electronic picture desk in less than a minute. Again, quick and clean at the highest quality with no prints.

But digital cameras are really the answer.

A digital picture is likely to be an important part of the newsroom of the future.

Pictures handled digitally from the news scene, to the newsroom, to the production department and onto the press will mean a savings in supplies and manpower.

A digital picture is likely to be an important part of the newsroom of the future.

That journey will work this way: A photographer at the scene of a fire, for instance, will transmit his digital image by a cellular phone hookup, or a nearby pay phone, or the newspaper's two-way radio system. Virtually an instant picture for the upcoming edition.

At the newspaper, this image will be taken into an electronic picture desk for handling. A picture editor will view, crop, and size the photo, and do any toning needed. That picture editor will then electronically send the completed picture into the newspaper's pagination system.

An editor at a pagination terminal will place the sized and toned picture electronically onto the page, and send the completed page - words and pictures - to the production department.

A plate will be electronically generated from the pagination desk's data file, and the plate will be sent on

to the pressroom for the start of that day's editions. The distant future may have that plate step taken away, with the electronic data transferred directly to the newsprint.

The photographer is still at the scene to cover later events. No worry about getting the later film back to the newspaper for deadline handling. No handling of film or prints at the newspaper. No carrying of a print from place to place. No one has to get out of their chair to get a spot news picture into the paper. It's a clean, digital path from the news event to the printed page.

And, because that press plate will be only one generation away from the original image, higher quality is achieved.

Besides the quality issue, there are other considerations for newspapers looking to get into electronic pictures.

The first is how pictures are handled now at the paper. Electronic picture handling will forever change old ways of doing things.

It will take some adjustment by photographers.

They are used to handling their work, having control over the film by using different development techniques, and controlling the prints by burning and dodging - darkening and lightening selected parts of the print. Also, at many newspapers, photographers determine the cropping of the initial offering to the photo desk. With digital images, they'll most likely lose those controls over their work.

It will also take some adjustment for editors.

At most newspapers, editors now sit at their desks and look through stacks of prints. They will have to get used to looking at pictures on a monitor. No more holding up a picture for a colleague to see. Or passing those pictures around a table at a news meeting to determine the content of that day's newspaper. There

won't be any "touching" in the digital world of picture handling.

The labor aspect of picture handling will shift from the darkroom to the electronic picture desk. Many newspapers are seeing a move to fewer darkroom technicians, and less space for the labs, and more digital imaging technicians, and more space for picture terminals.

Ethical considerations come into play, also.

Many digital picture systems include manipulation tools that allow photos to be changed radically without leaving any evidence. People can be joined in a picture when they have never met, items can be removed or added to scenes. Retouching is elevated to new levels.

All of these things were possible in the past, but were much more labor intensive. The move to digital imaging systems has made those kinds of manipulations much easier.

It's so easy, that many newspapers are instituting guidelines prohibiting the use of the most sophisticated digital manipulation tools on news pictures. Credibility is the issue. Newspaper readers, knowing that one picture has been altered, may assume that all of the newspaper's pictures have been altered in some way. They are left wondering if each picture is real.

Many newspapers are adopting rules which limit the use of the machines to simple color corrections and cropping exercises. Others simply say "we just don't do it."

Alex Burrows of the Norfolk *Virginain-Pilot* says "there will be a few mistakes and those newspapers will regret it. Then, those newspapers will come back to the ethical center." Burrows sees the graphics editor as "the leading force in keeping their newspapers honest. You have to work to keep your own newspaper ethical."

Another fear is that, with pictures captured at the scene in digital form, there won't be any permanent record of what reality was. Now, there is a negative. In the future the data can be changed with no sign that it was ever tampered with. Technical people call it a "seamless" alteration.

And there are software programs in development where you won't even need a picture to create an image. "There are software programs where you can sit at a computer terminal," Wedding explains, "without ever going to a location or having a photograph of that place, and you are going to be able to create a lifelike photographic image of the scene."

> *"Whether we call it a photograph, or art work, an illustration, or a hybrid image, it is coming."*
> — GEORGE WEDDING

"Whether we call it a photograph, or art work, an illustration, or a hybrid image, it is coming," Wedding says.

"It is the same technology that is now used to create backdrops and animation in movies," he explains. "Those programs are now being ported over to small, relatively inexpensive, personal computers."

The issue of ethics in dealing with these new types of images is being discussed. "We haven't even begun dealing with the tip of the iceberg when you think of the software that is coming," Wedding says.

"It's one thing to alter an image," he says, "another thing completely to create an image from scratch."

But, the positive aspects of digital picture handling - from the photographer at a news scene to the handling of pictures at the newspaper - are a step forward and will result in better coverage for the reader.

"Just as 35mm photography changed the way photography was used back in the '30s," Wedding says, "I think the computer will change, yet again, how

photography is used. The 35mm camera brought candid photography into accepted use and electronic cameras and digital pictures are going to have that same profound effect in the '90s. I think that computers are going to help us get pictures faster, with higher quality, and be more competitive with TV."

Binks says, "Photographers better understand it is impending, and to learn what they can about the new methods. Learn about using the new camera, and try not to be sitting there" when the change comes. Binks says today's photographers shouldn't be caught, like many were "with the 4x5 when the 35mm came along."

The electronic camera "will come, and it will not be hastened by the photographers, it will be hastened by the publishers," seeking to gain efficiency and quality, Binks says.

But, for the photographer, the discussions of cost factors and other gains are second to talk of what the next horizon for photography will hold.

Computers and electronic cameras, Wedding says, "are also going to help extend our creativity and allow us to practice new and unique styles of photography."

CONTRIBUTORS

The following people are quoted, or have photographs, in this book.

Baumann, J. Bruce – assistant managing editor for graphics, *The Pittsburgh Press*

Binks, Porter – picture editor, *USA Today*

Breslauer, David – staff photographer, The Associated Press, Austin

Burrows, Alex – chief picture editor, the *Virginian-Pilot*, Norfolk

Cabluck, Harry – NewsPhoto Editor, The Associated Press, Dallas

Carter, Mary Ann – freelance photographer, Indianapolis

Corn, Jack – director of photography, the *Chicago Tribune*

Counts, Wyatt – freelance photographer, New York

Daugherty, Bob – staff photographer, The Associated Press, Washington

Duncan, Mark – staff photographer, The Associated Press, Cleveland

Eisert, Sandra – senior picture editor, the *San Jose Mercury News*

Endlicher, Diether – staff photographer, The Associated Press, Munich

Foggia, Gianni – staff photographer, The Associated Press, Rome

Foster, Mimi Fuller – picture editor, *The Atlanta Journal and Constitution*

Gaps III, John – staff photographer, The Associated Press, Des Moines

Hardin, C. Thomas – photo and graphics editor, the *Courier Journal*, Louisville

Kennedy, Rusty – staff photographer, The Associated Press, Philadelphia

Lee, Nancy – deputy picture editor, the *New York Times*

Lennihan, Mark – staff photographer, The Associated Press, New York

Longstreath, David – staff photographer, The Associated Press, Oklahoma City

McLendon, Lennox – staff photographer, The Associated Press, Detroit

Mutschler, Kurt – picture editor, the New Orleans *Times-Picayune*

Nighswander, Larry – illustrations editor, *National Geographic World*, Washington

Parker, David – freelance photographer, Indianapolis

Perry, Scott – freelance photographer, Portland, Maine

Pizac, Douglas C. – staff photographer, The Associated Press, Los Angeles

Ragan, Susan – staff photographer, The Associated Press, New York

Rehg, R. Jonathan – freelance photographer, St. Louis

Reinke, Ed – staff photographer, The Associated Press, Louisville

Risberg, Eric – staff photographer, The Associated Press, San Francisco

Sancetta, Amy – staff photographer, The Associated Press, Philadelphia

Ut, Huynh Cong – staff photographer, The Associated Press, Los Angeles

Wedding, George – director of photography, *The Sacramento Bee*

Widener, Jeff – staff photographer, The Associated Press, Bangkok

Widman, George – staff photographer, The Associated Press, Philadelphia

Zalubowski, David – freelance photographer, Denver